Type Rules!

Ilene Strizver

NORTH LIGHT BOOKS
CINCINNATI, OHIO

www.howdesign.com

Visit our Web site at www.howdesign.com for information on more resources for graphic designers. Other fine North Light Books are available from your local bookstore, art supply store or direct from the publisher.

05 04 03 02 01 5 4 3 2 1

Library of Congress Cataloging-in-Publication Data

Strizver, Ilene
 Type rules! / Ilene Strizver
 p. cm.
 Includes bibliographical references and index.
 ISBN 1-58180-047-9 (hc: alk. paper)
 1. Type and type-founding. 2. Graphic design (Typography) I. Title.

Z250 .S92 2001
686.2'21—dc21 00-064736

Editor: Clare Warmke
Interior designer: Ilene Strizver
Cover designer: Matthew Gaynor
Interior production artist: Ruth Preston
Production coordinator: Emily Gross

ACKNOWLEDGMENTS

As a person whose academic beginnings were focused on music and fine art, I have been extremely lucky to have had my path crossed by some of the most open-hearted and talented individuals in the world of typography and graphic design, almost in spite of myself. They permanently altered my life's path and I will forever be indebted to them. Aaron Burns and Ed Benguiat are the primary culprits, joined by the likes of Herb Lubalin, Bob Farber and Allan Haley. Their creative brilliance coupled with their incredible generosity of spirit ignited within me a passion for type that will never be satiated.

Throughout the years, there have been countless graphic designers, type designers, typographers and other creative professionals who have unselfishly shared their years of knowledge and passion for type and design with me; to all of them, I offer my deepest thanks, for without them, this book never would have come to be.

I also want to extend warm thanks to my special friends Maxim Zhukov, Fred Brady and Christopher Slye, who so very generously offered their time and professional assistance to help make this a better book. And last but not least, a very special thanks to Lynn Haller, who as my initial editor supported this first time writer in molding this book into my own vision of what it should be.

DEDICATION

This book is dedicated to my father, Leonard Strizver, who taught me to believe in myself and that the sky was the limit to what I could accomplish, but didn't live long enough to see his words take shape in my life. I hope I've made you proud, dad.

TABLE OF CONTENTS

INTRODUCTION

Type is all around us: everywhere from the grocery store to TV commercials to greeting cards as well as books, magazines and storefronts. Learning to read and write the alphabet is one of the first things we are taught in school, and that process often begins before nursery school with television shows and videos intended for the hungry and curious minds of two- and three-year-olds.

Type and printed matter not only communicate information to us, but they also influence decisions we make on a daily basis. Whether we realize it or not, type and the way it appears affects which CD and book cover catches our eye, which detergent might make the whites whiter, and which movie might be the scariest or most romantic. Much of this process goes on unconsciously, which is why the art and craft of typography is so invisible to the average person. But its unseen nature by no means diminishes the importance and influence type has on the quality and substance of our daily lives.

Type Rules! is intended for anyone interested in typography, be they a novice computer user or a professional graphic designer. There is something here for everyone, whether you know a little or a lot about type. This book does not have to be read from front to back; you can thumb through the chapters and stop wherever something sparks your interest, or read it chapter to chapter. This book will stimulate and satisfy the neophyte's interest in type as well as offer advanced information and techniques to the professional graphic designer wanting to improve their work.

Typography is not taught in many design schools. When it is, the concentration is usually on typographic design in its broadest sense, not the nuts and bolts of how to set type tastefully and effectively; addressing this void is my primary objective. The intention of this book is to help you learn how to communicate effectively and professionally with type using features available in most page layout programs. It is not meant to teach you how to use your software; there are user manuals and numerous books, tapes and CDs to do that.

I can trace my interest in type and letterforms back to the posters I drew for my junior high school elections. I can remember spending hours on the lettering, measuring out the strokes of each character, the spaces between each letter as well as the spaces between the lines. Those posters would appear extremely crude by professional standards, but my interest in the geometry of letters and the relationships between their positive and negative spaces was evident even then.

After studying music and then fine art in college, I was lucky enough to have landed a seat in Ed Benguiat's lettering class at the School of Visual Arts in New York City; my life was never to be the same again. Ed instilled within me the passion for type that I have today, and that with which I will attempt to infect you. The bad news is if I succeed, there is really no cure for it; the good news is "catching it" will open your eyes to so many exciting things you have never seen before, and allow you to enjoy and appreciate the world around you in a completely new way.

A BRIEF HISTORY OF TYPE

he story of type doesn't actually begin with type per se, but with the beginning of mankind and civilization. Type has only existed for about 550 years, but its beginnings are rooted in the life of the caveman himself, as it was his developing needs and habits which led civilization on a path toward the evolution of the alphabet, and subsequently, the invention of type and printing. It is certainly possible to learn to use type effectively, and even tastefully, without knowing about its roots, but in order to fully understand and appreciate type today, it is important to know something of the past.

Milestones in the history of type are highlighted throughout this chapter. Some of the dates, chronology and details vary from source to source, but the spirit of the events remains the same; these events have taken mankind on a glorious ride from the crudest forms of cave drawings to the bits and bytes of type in the digital age.

SOUNDS TO SYMBOLS

For many years, early man communicated purely with sound. Verbal language which is heard and not seen, as opposed to visual language (or visible language, as it is often called), has many limitations: it is gone the instant it is spoken and heard, and is therefore very temporary. Stories, history and other information could not be passed on from generation to generation in a permanent way, only by direct word of mouth.

The earliest attempts to record stories and ideas were through cave drawings; the first known dated around 25,000 B.C. These drawings, or *pictographs,* were very simple representations of people, places and things, and for this reason, were relatively easy to learn and understand. Although this was a very simplistic form of written communication, it was certainly more permanent than sound, and

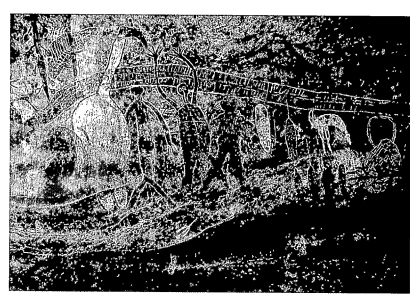

much of it has survived the ravages of time and still exists today.

Around 3000 B.C., the Sumerians developed *cuneiforms,* a system of writing that consisted of wedge-shaped forms carved into clay tablets and other hard surfaces. Cuneiforms evolved from the pictographs that the Sumerians had adapted earlier, and were one of the first systems of writing to read left to right. Its wedge-shaped forms were the result of the increasing use of a stylus. The straight edges and triangular corners of the stylus produced the geometric forms of the cuneiforms.

As time passed there was a need for more symbols to represent ideas and other concepts in addition to just "things." This led to the development of *ideograms,* or symbols representing ideas and actions. This new, expanded system was more difficult for the masses to understand, as it was not purely representational, but more symbolic in nature. This separated society into two groups: those who could understand this system, and those who could not. The spoken and written language had become very different from each other, requiring the learning of two unrelated systems of communication.

As society became more complex, the existing system did not meet its increasing needs and was no longer satisfactory; something more was needed. This need subsequently led to the development of letter symbols which when put together, represented words.

The Phoenicians, a society of traders and skilled craftsmen on the Mediterranean Eastern Coast, took written language a giant

PHOENICIAN	NAME	PHONETIC NAME	EARLY GREEK	CLASSICAL GREEK	NAME	GREEK	ENGLISH
⟜	aleph		Δ	A	alpha	A α	a
⩔	beth	b	日	B	beta	B β	b
∧	gimel	g	1	Γ	gamma	Γ γ	g
◁	daleth	d	Δ	△	delta	Δ δ	d
⧣	he	h	⧣	E	epsilon	E ε	e
Y	waw	w	⫠		digamma		
I	zayin	z	I	Z	zeta	Z ζ	z
日	heth	ḥ	日	H	eta	H η	ê
⊗	teth	ṭ	⊗	θ	theta	Θ θ	th
⤳	yod	y	⟨	I	iota	I ι	i
⩚	kaph	k	⟩	K	kappa	K κ	k
⌈	lamed	l	⌐	Λ	lambda	Λ λ	l
⩗	mem	m	⩘	M	mu	M μ	m
⩁	nun	n	⩁	N	nu	N ν	n
⧻	samekh	s			xi	Ξ ξ	x
O	ayin		O	O	omicron	O ο	o
⟩	pe	p	⟩	Π	pi	Π π	p
⩩	sade	s	M		san		
⊕	qoph	q	⊕		qoppa		
⪥	reš	r	⪥	P	rho	P ρ	r
W	šin	sh/s	⟩	Σ	sigma	Σ σς	s
X	taw	t	X		tau	T τ	t
				Y	upsilon	Y υ	u, y
					phi	Φ φ	ph
				X	chi	X χ	kh
					psi	Ψ ψ	ps
				Ω	omega	Ω ω	ô

This chart shows the evolution of the Greek alphabet, originally adapted from the twenty-two-character, all-consonant Phoenician alphabet. The Greeks added several new characters as well as vowels.

step ahead from the pictograms and ideograms. Around 1000 B.C. they developed twenty-two symbols that corresponded to the twenty-two key sounds of their language. Their idea was to connect the twenty-two symbols representing written sounds to imitate the spoken words, eliminating the memorization of hundreds of unrelated symbols. This unique concept was the first attempt to connect the written language with the spoken word; we now call this *phonetics*.

Around 800 B.C., the Greeks embraced the Phoenician invention and took it one step further by adding vowels and naming the symbols. They also employed *boustrophedon* (meaning "as the ox plows"), a system where one reads from left to right on one line, and right to left on the next.

Much later, the Romans, a highly developed society, made further changes by adding more letters, bringing this writing system even closer to our modern-day alphabet. They made other advances as well. The Roman scribes, in their attempt to write more quickly and efficiently, began joining and slanting the letters in harmony with the natural motion of the hand. They also added ascenders and descenders (see definitions in chapter three), as well as condensed forms of the alphabet to conserve valuable space.

One of the most important contributions to early writing by the Romans was Trajan's column, dated 114 A.D. It showcases one of the most beautiful and best-known examples of Roman letterforms. The lettering, which is incised at the base of the column, is a classical, elegant and exquisitely balanced combination of form, proportion and

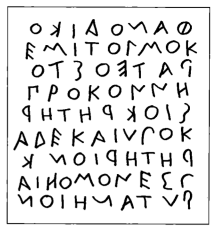

The Greek writing system employed *bous-trophedon (meaning "as the ox plows"), a system where one reads alternately from left to right on one line and right to left on the next. Notice how the letters are reversed from one line to another.*

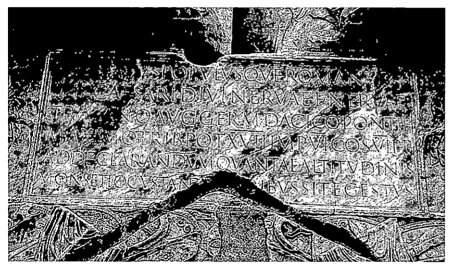

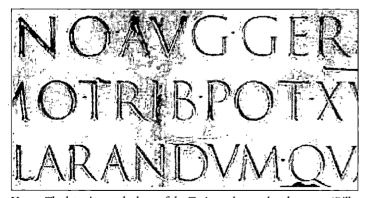

Upper: *The lettering at the base of the Trajan column, dated 114 A.D. (Bill Thayer)* Lower: *Close-up of the inscription on the base of the Trajan column, considered to be one of the most beautiful and best-known examples of Roman letterforms.* (Bill Thayer & Graphion)

simplicity. It has been, and continues to be, an inspiration to type designers worldwide.

Special mention should be made here of the tremendous contributions to the art of writing by the Chinese and other Asian cultures. Although their writing systems are not alphabetic, but rather consist of thousands of symbols, their extreme artistry, subtlety of form and mastery of the art of calligraphy have been a continuous source of beauty, poetic elegance and inspiration to all who come in contact with them.

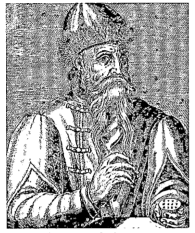

Engraved portrait of Johannes Gutenberg from Andre Thevet's Les Vrais Portraits et Vie des Hommes, *Paris, 1584. (Huntington Library)*

GUTENBERG AND MOVABLE TYPE

Until the fifteenth century, all books were hand-copied by scribes, as exemplified by the many breathtakingly beautiful and exquisitely written and illustrated manuscripts that were created for religious purposes in monasteries.

In 1448, that all changed with the birth of printing, after which the world would never be quite the same. Johannes Gutenberg, a goldsmith from Mainz, Germany, is credited with the invention of movable type. (There is some controversy about that, as some credit Laurens Coster of Haarlem in the Netherlands with its invention.) Gutenberg accomplished this by carving the characters of the alphabet in relief onto metal punches, which were then driven into other pieces of metal called matrices. Molten metal was then poured into these matrices, making the actual type, which was identical to the original relief punches. The type was then fit into printing presses that were capable of printing multiple images in a very short time. This was called letterpress printing, and had the distinctive characteristic of each character making a slight impression on the paper, giving it a rich, tactile quality.

Early type design imitated the pen-drawn styles of the scribes. Gutenberg's first typeface was in the style of the heavy blackletter popular in Germany at that time, and contained over three hundred characters, including ligatures and abbreviations. As the popularity of printing became more widespread, a variety of different typestyles emerged based on popular handwriting styles of that time, including those favored by Italian humanist scholars. Nicolas Jenson and Aldus Manutius were two printers of the time who designed typestyles that were influential and inspirational, even to this day.

Gutenberg then went on to print the Bible, the first book printed from movable type. This invention truly changed the world, as it was no longer necessary for scribes to spend months and years (and lifetimes, actually) hand-copying books.

Close-up of the blackletter typeface used to set the Gutenberg Bible.

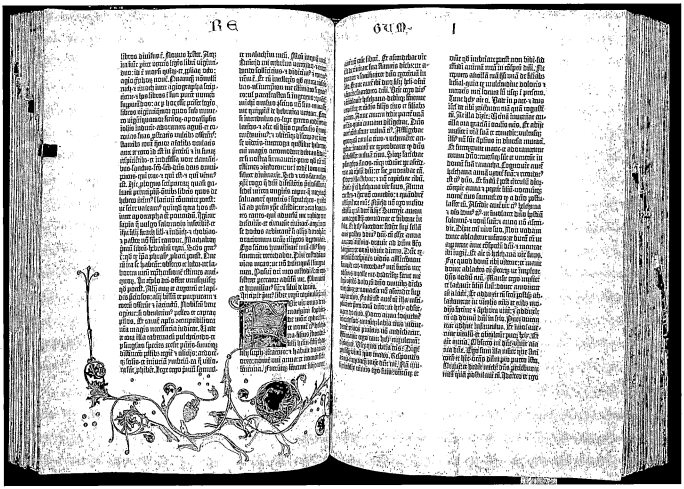

A spread from the Gutenberg Bible, the first book printed from movable type. Beginning of the Book of I Kings. Mainz, 1450–5. (Huntington Library)

This historical milestone, which now enabled history, news, religious writings and other kinds of information to be circulated more easily and freely, brought forth many other changes, such as improvements in printing presses, papers and inks. It also inspired many others to design typefaces to make use of this transformational invention.

Type designers were extremely influential in shaping the printed word over the centuries. The sixteenth century brought us the beautiful proportions of the work of Claude Garamond and Robert Granjon. In the next hundred years, the balanced designs and readable typestyles of William Caslon emerged. Giambattista Bodoni and Firmin Didot were tremendously influential in the eighteenth century with their elegant and graceful designs. The nineteenth century gave way to the oldstyle characteristics of William Morris's work, and the twentieth century brought us many designs inspired by the geometric Bauhaus style. Many thousands of typeface styles available to us today are in large part due to the originality, artistry and craftsmanship of five centuries of talented printers and designers, only a handful of which are highlighted here.

At this point in history it is important to note the influence that the actual technology had on the look of type. The new printing technology with all its exciting advances as well as the many beautiful and functional type-

De diſſectione partium corporis humani, Liber ſecundus.

Proœmium.

Væ partes in humano corpore ſolidiores & exteriores erant,quæ'q; ipſam machinam potiſſimum conſtituebant,ſatis iam explicatæ nobis videntur libro ſuperiore.Sequitur,vt internas percurramus quæ maximè pertinent ad vitam , & ad earum facultatum quibus incolumes viuimus conſeruationem.In quo(quemadmodū inſtituimus) ſubſtantia,ſitus,forma,numerus,cōnexio,earum partium de quibus ſermo futurus eſt,breuiter exponenda. Ad quod munus ſtatim aggrediemur,ſi pauca prius de inſtituto ac de iudicio noſtro ſubiunxerimus.Quanq̃ enim hic noſter in ſcribendo ac diſſecan do labor,complures non modo in anatomes cognitione,ſed etiam in Galeni ſententiæ interpretatione iuuare poterit:tamen interdū veremur,ne quibuſdam nomen hoc anatomicum ſit inuiſum : mirentúrq; in ea diſſectione tantum nos operæ & temporis ponere: cum alioqui ab ijs qui nummorum potius quàm artis aucupio dant operam facile negligatur.Atq; ita nobis oc curritur,dum quærunt:ſatiſne conſtanter facere videamur,qui cum corporis humani partiū longiori indagationi ſtudemus , quæ magis ſunt vtilia, imprimiſq; neceſſaria prætermittimus:ſatius eſſe affirmantes,eius rei cogni tionem ſicco (vt aiūt)pede percurrere,in qua alia certa,alia incerta eſſe di

Margin notes: Quid dictum libro ſuperiore.

Quid ſecūdo libro dicetur.

Purgatio aduerſus eos, qui longiorem anatomes indagationem minus probat

Roman type by Claude Garamond from the print shop of Simon de Colines, Paris, 1545.

Sample of Firmin Didot type cut around 1800.

Actual Bodoni "type." Carved punches were driven into other pieces of metal called matrices. Molten metal was then poured into these matrices, making the actual type.

The grace and elegance of the type of Giambattista Bodoni is evident in this page from the Manuale Tipografico, *which is considered to be one of the greatest type specimen books ever printed. (1818)*

REALE

Quousque tandem abutêre,Catilina, patientiâ no-

AQUINO

faces that were inspired by it also had its limitations, particularly when we look back from where we are now. Because each character was on a separate piece of metal, the space between the particular characters could not be adjusted to create a more even type color (known as "kerning") unless the letter combination was designed as a ligature or was combined on one piece of type. Additionally, line spacing could not be reduced beyond "setting solid," which allowed space for the ascenders and descenders. This meant that an all-cap setting had to have a lot of line spacing even if there were no ascenders and descenders. This created a very open, "letter spaced" look which was characteristic of that time and is still desired by some for its historical accuracy and its readability.

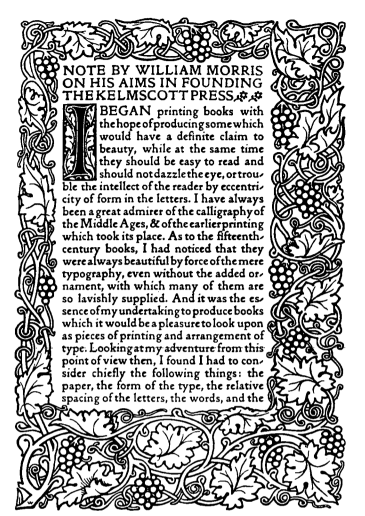

NOTE BY WILLIAM MORRIS ON HIS AIMS IN FOUNDING THE KELMSCOTT PRESS.

I BEGAN printing books with the hope of producing some which would have a definite claim to beauty, while at the same time they should be easy to read and should not dazzle the eye, or trouble the intellect of the reader by eccentricity of form in the letters. I have always been a great admirer of the calligraphy of the Middle Ages, & of the earlier printing which took its place. As to the fifteenth-century books, I had noticed that they were always beautiful by force of the mere typography, even without the added ornament, with which many of them are so lavishly supplied. And it was the essence of my undertaking to produce books which it would be a pleasure to look upon as pieces of printing and arrangement of type. Looking at my adventure from this point of view then, I found I had to consider chiefly the following things: the paper, the form of the type, the relative spacing of the letters, the words, and the

Golden Type and page border by William Morris. From a note by William Morris on his aims in founding the Kelmscott Press. (Kelmscott Press, 1898)

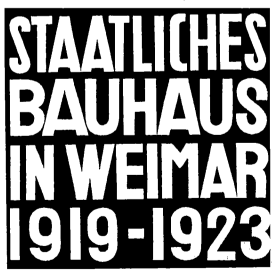

This cover design by Herbert Bayer illustrates the influence of the Bauhaus, c. 1923. (Original: red and blue letters on black background.)

abcdefghi jklmnopqr stuvwxyz

Typeface design by Herbert Bayer, 1925. This Bauhaus design is a minimalist sans serif "unicase" typeface.

PHOTOTYPE

The development of new and improved presses continued through the centuries, but it wasn't until the late nineteenth and early twentieth centuries that groundbreaking improvements in typesetting equipment were achieved.

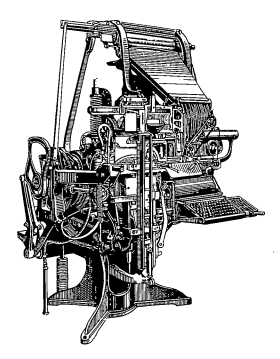

In addition to its lack of speed and reliability, one of the primary limitations of metal-type composition, as it is referred to, was the inability to justify type automatically, that is, without the manual insertion of metal spaces between the letters. The Linotype machine, invented by Ottmar Mergenthaler in the 1880s, as well as other typesetters that followed, including one from Monotype, sped up the printing process immensely (including justification) and finally eliminated the need to set type by hand one letter at a time. The greatly increased speed that resulted from the replacement of hand composition by machine composition had a major effect on newspapers by allowing them to extend their deadlines to print late-breaking news. This typesetting change went hand-in-hand with advancements in the printing industry, such as offset lithography, a photographic process that gradually replaced letterpress printing.

Linotype machine invented by Ottmar Mergenthaler.

Technology took a huge leap ahead in the mid-1950s with the development of phototypesetting. Several companies, the most prominent being Mergenthaler and Intertype, developed and improved a photographic process of setting type whereby typefaces were made into negatives through which light was focused onto photosensitive paper, producing an image of the type. The improvements over hot, metal typesetting were qualitative as well as quantitative. Typesetting could now be done electronically rather than mechanically, setting over five hundred characters per second compared to perhaps five or six previously, and the equipment took up much less space. Images became sharp and crisp, corrections could be made electronically, and most importantly, there was now complete flexibility with regard to intermixing styles, weights and sizes; letter spacing and kerning; line spacing and word spacing; hyphenation and justification; overlapping and other photographic special effects as well. The sudden elimination of so many restrictions in the typesetting process had a major effect on typography and typographic design.

HERB LUBALIN

One of the most prominent figures in typography and typographic design in the sixties and seventies was Herb Lubalin, a hot, innovative and fearless New York designer. His groundbreaking and adventuresome use of type, particularly in the publication *U&lc* (designed and edited by Lubalin and published by International Typeface Corporation) influenced designers around the globe. His work incorporated tight letter spacing and line spacing, extreme kerning with acute attention to every typographic detail, and the overall use of type and innovative new typefaces in ways never before seen. In addition, he handled type in

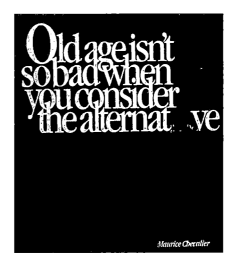

The work of Herb Lubalin broke with tradition in every possible way. He created the following three pieces for U&lc, the typographic journal published by International Typeface Corporation. As the editor and designer of U&lc, he was able to present his innovative typographic ideas in the perfect vehicle.

Above: This piece combines a bold typeface set with tight letter spacing and line spacing with a very elegant hand-lettered script to illustrate a point typographically.

Top right: The overlapping ascenders and descenders of this piece take a back seat to the dramatic effect of the "i" lying on its side. The message is visual as well as editorial.

Bottom right: The message expressed here with the use of very tightly set caps is made even stronger by the placement of black-and-white color breaks, especially in the word "equal."

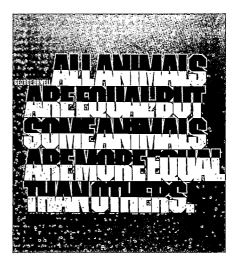

an illustrative way seldom done before, either by employing typographic forms as graphic elements of the design or by creating typographic puns.

Why did he do this? Because he could, as these were capabilities never before possible with type. The typographic trends initiated by Herb Lubalin and imitated by countless others, particularly the emphasis on tight type at the occasional expense of readability, were a reaction to the restrictions of the hot-metal typesetting that preceded them. This style has its critics (as well as its admirers) today, but it is important to understand how and why it came about in order to appreciate its tremendous importance and influence on the evolution of type and typographic design.

INTO THE DIGITAL AGE

The twentieth century continued to bring advances in typesetting technology at breakneck speed. Phototypesetting had been in use little more than two decades when digital typesetting methods took hold in the 1980s. Because it was so expensive and new, only professional typographers in type shops adapted this electronic technology. The new digital typesetters were capable of composing type and integrating photos and artwork and layout at one workstation. Digital color separation and retouch-

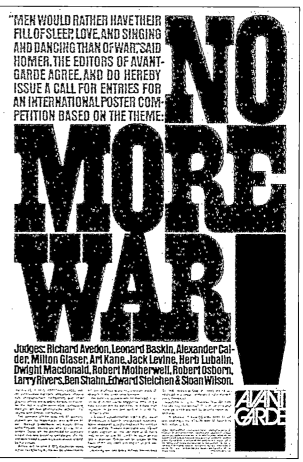

An announcement of an anti-war poster contest by Avant Garde *magazine. Herb's use of color, tight type and very deliberate type alignment (including hung punctuation) create a jigsaw puzzle effect in this powerful piece.*

ing, stripping and plate-making were to follow shortly. At this point, typesetting was still in the capable hands of professionals who spent many years learning the craft and trade of typography. This was all to change in the next few years.

In 1985, the world was irreversibly altered with the introduction of the Macintosh computer, the first affordable "desktop computer" developed by Apple under the leadership of Steve Jobs. Other manufacturers, led by IBM, were developing versions of their own which came to be known as personal computers or PCs. These PCs had different operating systems than Macs, but the same affordability and focus. Now it was possible for virtually anyone to set type on the computer as desktop publishing blazed the path toward desktop typography.

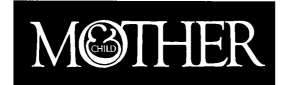

This award-winning logo designed for a never-published magazine not only states the name, but illustrates it as well. Herb considered the suggestion of a fetus inside the logo one of his finest typographic designs.

This new, exciting and increasingly more affordable technology was improving at every turn. At the same time, page-layout applications such as Adobe PageMaker and QuarkXPress, as well as the more illustration-oriented programs such as Adobe Illustrator and Aldus Freehand, were being developed. As the memory and speed of desktop computers increased, so did the features and capabilities of these programs, eventually including the ability to set and fine-tune type. Simultaneously, companies and foundries such as International Typeface Corporation (ITC), Adobe, Linotype, Compugraphics and Berthold shifted their focus to developing digital versions of their existing typeface libraries, as well as releasing new and different designs. Smaller, more specialized foundries such as FontBureau, Emigre, T-26 and FontShop began to emerge and introduced some very innovative and cutting-edge type designs. The introduction of type design programs such as Letraset FontStudio, Macromedia Fontographer and Ikarus-M afforded the ability to create fonts to anyone who wanted to. These developments led to the democratization of type design, and contributed to the many thousands of fonts commercially available today. The quality of these typefaces ranged from very high end to extremely poor, leaving the daunting task of deciphering "which was which" up to the end user.

Graphic design production methods were changing in dramatic ways as well. Paste-ups and mechanicals (the manual creation of camera-ready artwork using paper proofs and wax or rubber cement) were being replaced by digital page makeup, which was cheaper, faster and much more flexible. Type no longer needed to be sent out to expensive type shops and instead was being set by graphic designers and production artists, as well as administrative assistants.

The problem with this new way of setting type is why a book like this exists. Setting good typography is an art and craft that in the past took many years to learn and required highly skilled professionals who devoted their careers to that end. Today, however, most of those working with typography have little education in type, including, with few exceptions, most designers (although some of the better design schools are just beginning to address this important subject). The unfortunate result of this situation has been the proliferation of poor typography.

Another contributing factor to this problem was that the earliest versions of page-layout programs didn't have the capability to fine-tune type. Thankfully, today's updated software programs are much more sophisticated and robust and are quite capable of creating excellent typography, but it still requires a skilled and knowledgeable person to achieve this. The computer is just a tool; it is a means to an end, not an end in itself. Many designers and production artists are not versed in the factors that contribute to the creation of fine typography and are not aware of and familiar with the features in their page-layout programs that can achieve this. With practice, however, you will acquire the eye necessary to see type as a professional does, as well as the ability and motivation to create it.

in order
to under
rstand
typeon
the come
puters
now what
it looks
and act
sthew

FROM METAL TO MAC:
UNDERSTANDING FONT TECHNOLOGY

ay the word "technology" to a lot of folks and they instantly break out in a cold sweat. But in order to understand type on the computer, know why it looks and acts the way it does, and learn how to make the most of it, it is essential to comprehend a few things.

These are just a few of the most commonly used (and perhaps abused) terms that will begin to give you an understanding of the basic principles of type and fonts on the computer.

WHAT IS A FONT?

What exactly is a font? The term has changed dramatically since computers have come into being. In traditional typography, specifically in days of metal type (or hot type), a font was a collection of metal characters representing the complete character set of a particular design (all the characters, numerals, signs, symbols, etc.), all of the same weight, style and size. Ten point, twelve point and any other size of the same design were all separate fonts.

Today, a font refers to the complete character set of a particular type design or typeface in digital form. Although it refers to only one weight and style, it is not size-specific as in the days of hot metal. Digital fonts are scalable, that is, size-independent; any point size type can be set from one font.

FONT FORMATS

Type 1 and TrueType are the two most commonly used font formats, and both formats are used on Mac and Windows (but not necessarily with all typefaces). For various reasons both technical and political, Type 1 has become the flavor of choice for Mac users, while TrueType is generally favored by Windows users. But if you are doing graphic design work (which is the assumption if you are reading this), Type 1 is the preferred format, even if you are using a PC.

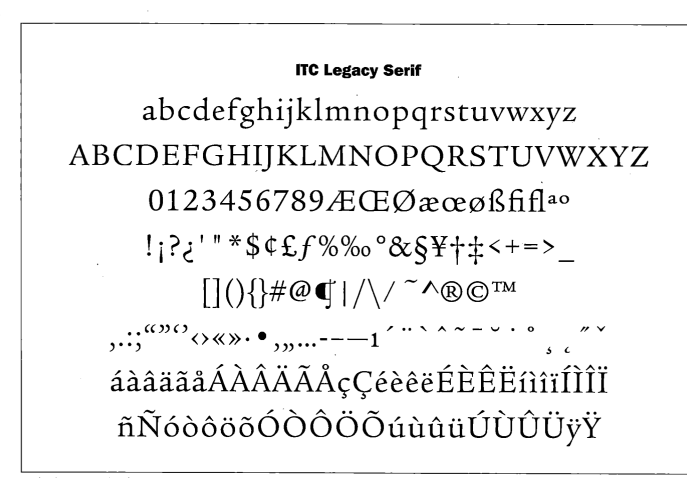

ITC Legacy Serif

abcdefghijklmnopqrstuvwxyz
ABCDEFGHIJKLMNOPQRSTUVWXYZ
0123456789ÆŒØæœøßfifl ᵃᵒ
! ¡ ? ¿ ' " * $ ¢ £ ƒ % ‰ ° & § ¥ † ‡ < + = > _
[] () { } # @ ¶ | / \ / ˜ ^ ® © ™

In the digital world, a font refers to the complete character set of a particular type design or typeface in digital form. This showing of ITC Legacy Serif is a good example, and displays all the glyphs included in the font.

In order to understand the differences between Type 1 and TrueType fonts as well as their various components, it is necessary to get a bit technical. But don't worry: you don't have to commit this to memory to set good type. Just try to remember the basic principles.

TYPE 1 (OR POSTSCRIPT) FONTS

Type 1 fonts depend on a computer language called *PostScript;* all Type 1 fonts are PostScript fonts, and the reverse is true as well (all PostScript fonts are Type 1 fonts). PostScript is the name of a page description language developed by Adobe Systems. It is a robust computer language used to describe type, graphics and page layouts in a way that allows them to be printed precisely and sharply at any size by a PostScript printer. These kinds of printers have a built-in intelligence that interprets this language and renders the image. This intelligence is, in a sense, a mini computer in its own right, which is why PostScript printers are more costly than non-Postscript printers.

There are also PostScript clone printers which imitate this ability and intelligence, but do not use the original proprietary Adobe PostScript code (and don't pay Adobe a royalty), and therefore are less expensive.

BIT-MAPPED OR SCREEN FONTS

Type 1 fonts are made up of two components: a bit-mapped "screen" font and a printer "outline" font. Your screen represents all images, both graphics and type, with small dots, or more accurately, pixels. The typical screen has 72 dots per inch, commonly abbreviated as 72 dpi. In a bit-mapped font all the characters are represented as pixels, or bitmaps, so it can be viewed on your screen, thus the name screen font. The relatively low number of dots per inch of your screen (also referred to as screen resolution) compared to your printer makes smaller point sizes increasingly more difficult to display sharply and clearly, giving them the appearance of having more "jaggies." This is why text can often be difficult to read on your screen.

This suitcase icon (as opposed to Suitcase with a cap S) is the part of the PostScript Type 1 font which contains one or more screen fonts.

In a bit-mapped font all the characters are represented as pixels so it can be viewed on your screen. This illustration shows the arrangement of pixels for a character at a particular point size superimposed over the outline.

The screen fonts supplied with your font are sometimes hand-edited to make them read as clearly as possible on your screen. This is more often done by the larger, more reputable manufacturers who have the skill and resources to do this. In order for you to know which screen fonts are actually installed in your system, most software applications will display those sizes as outlined numerals in the size menu.

Every point size needs to be represented by a different arrangement of pixels on your screen, but a screen font for every size would make the font much too large. For this reason, this function is assigned to a utility called Adobe Type Manager, or ATM (see next page), which makes screen fonts for every point size on the fly. The screen font is usually represented as a little suitcase, not to be confused with the type management utility, Suitcase.

PRINTER OR OUTLINE FONTS

This is the part of the font that is necessary to print your job. It is essentially the outline of each character stored as a mathematical description, thus the name "outline font." The printer font is scalable, which means it can be enlarged or reduced to just about any size, rendering as crisp and sharp an image as your

These are just two of the most common (and somewhat generic) icons used to represent printer fonts. Many manufacturers have their own personalized versions.

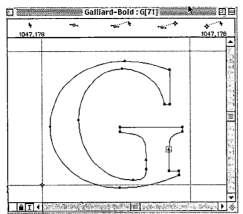

The image above is a digital representation of an outline. A printer font is scalable, which means it can be enlarged or reduced to any size, rendering as crisp and sharp an image as your printer or output device is capable of printing.

printer or output device is capable of. Your PostScript printer acts as the brain which does this interpretation. (This is quite the opposite of the screen font, which is fixed and needs to be generated for each size.)

The AFM file, which stands for Adobe Font Metrics, is supplied with most Type 1 fonts. It contains a lot of the technical specifications of the font, including exact measurements related to the character height, width, ascenders, descenders, side bearings and kerning pairs. It does not actually need to be stored in your computer in order for you to set or print type. To save space in your disk, don't bother loading it.

This icon represents the AFM, or Adobe Font Metrics file. Don't mistake it for a screen font icon which has a turned down left corner, especially if you choose to discard these.

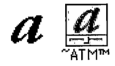

Both of these are icons for Adobe Type Manager (ATM).

ADOBE TYPE MANAGER (ATM)

ATM is a priceless utility that makes Type 1 fonts look crisp and sharp on screen at any size. Without it, the only point sizes that look relatively smooth on your screen are the ones that have their own screen fonts installed. Without ATM, the appearance gets increasingly worse as point size gets larger. ATM actually takes the printer font (remember it is an outline) and rasterizes it, or instantly converts it into an arrangement of pixels for the required point size. It generally does a good job of it, and if the installed bitmaps for a font have not been hand-edited, ATM can actually create a better version than the ones supplied. So why load any screen fonts in your system at all then? The reason is that at least one size needs to be installed for a font to be listed in the font menu of your software.

NOTE: ATM cannot work with fonts resident in your printer, as opposed to those that are loaded into your hard drive (HD), as it doesn't have access to the outlines that are stored in your printer.

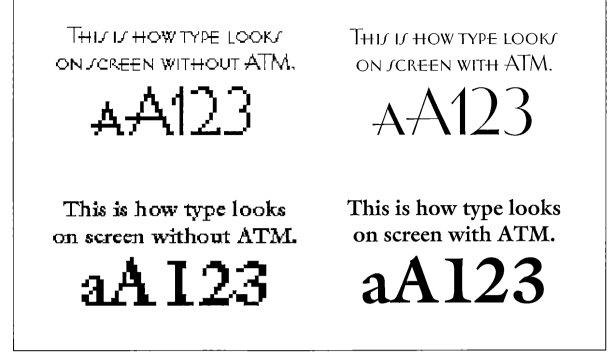

THIɾ Iɾ HOW TYPE LOOKɾ
ON ɾCREEN WITHOUT ATM.

A̶A̶123

THIɾ Iɾ HOW TYPE LOOKɾ
ON ɾCREEN WITH ATM.

A̶A̶123

This is how type looks
on screen without ATM.

aA123

This is how type looks
on screen with ATM.

aA123

Without ATM loaded and turned on, the appearance of type on the screen is extremely jagged and hard to read in sizes other than those bit-map fonts loaded into your system; it gets worse as the point size gets larger. As you can see, the appearance improves dramatically with ATM–the larger the type, the better it gets!

TRUETYPE

This is the "other" font format, developed by Apple in conjunction with Microsoft. It is a different format, but is similar to Type 1 in some ways. It is also a scalable font, but instead of having a printer font and a screen font, a TrueType font has all the information stored in one font file. The Mac OS and Windows have rasterizers that create smooth screen fonts for all sizes from this one file, and ATM isn't needed to accomplish this. TrueType doesn't require a PostScript printer or clone to print well either.

TrueType font icons have three As in comparison to Type 1 fonts, which have only one A.

TrueType might sound great to you, but keep in mind that the graphic design community favors Type 1 fonts, which are preferred for the quality of their output and their reliability. This is particularly so if you intend to output your work at a service bureau (or at your [offset] printer if they are making the film), as they usually gripe at jobs using TrueType fonts. If you are using them, it is a good idea to discuss this in advance with your service bureau to see what their policy is and if they have any special instructions. TrueType fonts are fine for word processing jobs that have no printing considerations.

If you have a font in both formats on your system, which can happen when you download one that is also resident in your system or was supplied with software you previously downloaded, it will cause confusion and problems when printing, so it is best to remove one. If you don't know which you have, you can look at the font icon: TrueType font files have three *As* on their icon, as opposed to one *A* in a Type 1 font.

MULTIPLE MASTER

This font technology, originally developed by Adobe, allows the user to create a virtually unlimited number of variations of a typeface. A multiple master font contains extreme, outer versions of the font with varying characteristics, such as light and bold, wide and narrow, optical variations for each point size, or sometimes even serif and sans. With a minor effort, you are able to create hundreds of versions of fonts with design characteristics in between all the supplied versions. These interpolated fonts are proportionally accurate and esthetically pleasing, unlike the font variations created using the expand, condense and embolden features in page layout programs. Multiple Master (MM) fonts are useful if you are doing jobs where you need very specific widths or weight variations of a typeface to fit in a certain space, or just for the design flexibility multiple master type gives you.

The markings around this character illustrate the hints, or instructions, that have been incorporated into a font to make type look good on screen as well as when printed.

HINTING

Hints are instructions that have been incorporated into a font to make your type look good on the screen as well as when printed. Remember that your printer converts all images into dots? Well, the hints tell your printer which dots to turn on and which to turn off when converting the scalable outline into the screen and printed version. This function is particularly necessary to improve the quality of type on the screen as well as low-resolution printers, 300-dpi printers in particular. This is less of a problem for printers that are 600 dpi and up.

SUITCASE

Suitcase (available from Extensis) is one of several font managing utilities that is very helpful when you have lots of fonts which you use for different jobs. It is a way of organizing your fonts and accessing just the ones you need for a particular job

Extensis Suitcase 8 icon.

without having to move them in and out of your Fonts folder located in your System folder. This way they don't take up valuable space on your random access memory (RAM), and you don't have ridiculously long font listings on the font menu of your application.

Suitcase 8, as well as some other programs, identify font naming or number conflicts and fix them on the fly. ATM Deluxe (Adobe) is the latest, very robust version of ATM and can perform many of the same functions as Suitcase, as well as several other programs such as Font Reserve (Diamondsoft) and MasterJuggler Pro (Alsoft).

WHAT MAKES A TYPEFACE LOOK THE WAY IT DOES?

Why are there so many typefaces? Why do we need new ones? And what are the differences between them all? These are some of the most commonly asked questions about type, and understandably so. With over forty thousand typefaces in existence and new ones being designed as we speak, both the novice and the professional can easily become lost in a sea of typoconfusion.

Type design is similar to other kinds of product design in that it combines personal expression and interpretation with the needs and trends of the times. As technology changes, so does society as a whole, and changing personal tastes and styles are often a reflection of this, as is the desire to stand out from the crowd. Automobiles, furniture, watches, clothing and even household items such as telephones, toasters and teacups are all essential, functional items which are constantly changing and being redesigned, and subsequently being purchased anew or replaced by consumers. We never seem to have enough choices. The same is true for typefaces, with one major difference: the appropriate choice of a typeface is essential to the success and effectiveness of your message.

Some typefaces, such as text faces, are chosen for their functionality, while others are chosen to be new and different and eye-catching, as are most display designs. Before we can *understand* the differences between typefaces, it is important to be able to *see* the differences. This is an acquired skill which can be learned by anyone who is interested, akin to using a muscle you've never used before in a sport, or acquiring a taste for different kinds of apples or beer. Many typefaces will look similar to the unskilled eye at first glance, but in time you will not only be able to see how they differ, but also understand how those differences are important to the effectiveness and appeal of your job.

PARTS OF A CHARACTER

Typefaces, or alphabets, consist of many different characters. Each character is made up of different parts, all of which have a name. Knowing this terminology, discussed in the following list, not only makes it easier to communicate about typefaces and their characteristics, but it will educate your eye to see and recognize the underlying structure of various designs and subsequently the differences between them.

Arm–A horizontal stroke that is attached on one end and free on the other.

Arm/leg–The upper or lower (horizontal or diagonal) stroke that is attached on one end and free on the other (K).

Ascender–The part of a lowercase character (b, d, f, h, k, l, t) that extends above the height of the lowercase x.

Bar–The horizontal stroke in characters such as the A, H, e, f.

Baseline–The invisible line on which most characters sit.

Bowl–A curved stroke which creates an enclosed space within a character (which is then called a counter).

Cap Height–The height of capital letters from the baseline to the top of caps, most accurately measured on a character with a flat bottom (E, H, I, etc.).

Counter–The partially or fully enclosed space within a character.

Descender–The part of a character (g, j, p, q, y and sometimes J) that descends below the baseline.

Ear–The small stroke that projects from the top of the lowercase g.

Hairline–A very thin stroke most often common to serif typefaces.

Link–The stroke that connects the top and bottom part (bowl and loop) of a two-story lowercase g.

Loop–The lower portion of the lowercase g.

Serif–The projections extending off the main strokes of the characters of serif typefaces. (See Serif under Type Categories on page 36.) Serifs come in two styles: bracketed and unbracketed. Brackets are the supportive curves which connect the serif to the stroke, creating a somewhat softer look. Unbracketed serifs are attached sharply, and usually at 90° angles.

Shoulder–The curved stroke of the h, m, n.

Spine–The main curved stroke of the S.

Spur–A small projection off a main stroke found on many capital Gs.

Stem–A straight vertical stroke or main straight diagonal stroke in a letter which has no verticals.

Stress–The direction of thickening in a curved stroke.

Stroke–A straight or curved line.

Swash–A fancy flourish replacing a terminal or serif.

Tail–The descender of a Q or short diagonal stroke of an R.

Terminal–The end of a stroke not terminated with a serif.

X-height–The height of lowercase letters, specifically the lowercase x, not including ascenders and descenders.

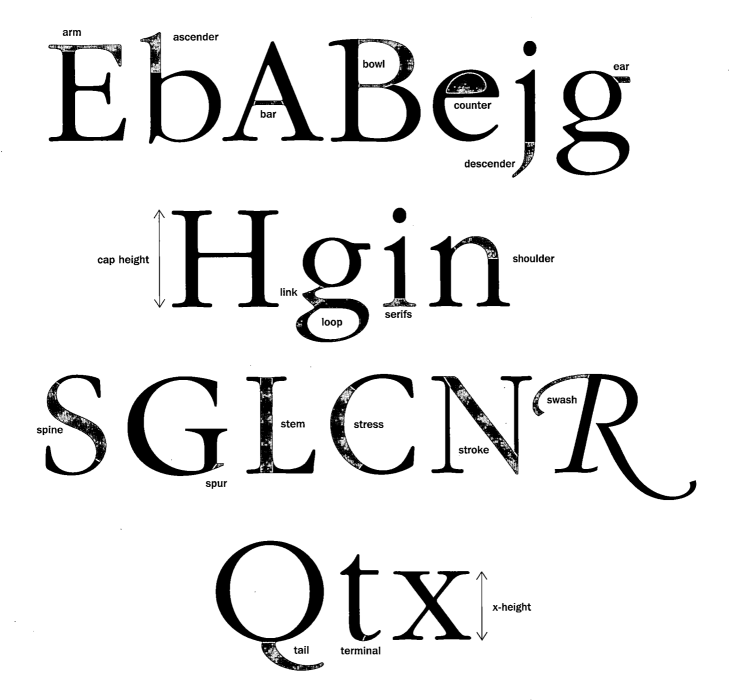

This chart illustrates the parts of a character.

TYPE CATEGORIES

Many attempts have been made to divide type styles into historic classifications, oftentimes resulting in a dry and somewhat cumbersome read. The following section will attempt to simplify and demystify the type classification system in order to give you a basic understanding of where the many hundreds of types came from, how they differ, and why.

Although it is not necessary to commit these categories to memory, there is value in understanding the origins of type and what makes one typeface different from another. Not only will you be building a good foundation for your growing typographic knowledge, but by reading about the differences between the typefaces, you will get a clearer picture of the anatomy of a character and how it varies from one typeface to another. It is an excellent way to fine-tune your ability to see type and know what you are looking at!

SERIF

This is a large category of typefaces with one common denominator: all have serifs. Simply put, serifs can be described as extensions, protrusions, or more elegantly put, finishing strokes extending from the ends of a character. Although they are decorative and stylistic in nature, they are said to enhance readability by guiding the eye from one character to the next. They also serve to distinguish typefaces with similar shapes from each other.

Many categories of typeface fall under this heading, with the primary ones described below.

Oldstyle

This category of typefaces was originated between the late fifteenth and the mid-eighteenth century. It is characterized by curved strokes with the axis inclined to the left, little contrast between thick and thin strokes, headserifs that are usually angled, and bracketed serifs.

abcdefghijklmnopqrstuvwxyz
ABCDEFGHIJKLMNOPQRSTUV

Adobe Caslon

Transitional
Typefaces within this category represent the eighteenth-century time of transition between oldstyle and modern design. They have the following characteristics: the axis of the curved strokes is barely inclined or more vertical than diagonal, there is more contrast between thick and thin strokes than in old style, and serifs are thinner, flat and bracketed.

abcdefghijklmnopqrstuvwxyz
ABCDEFGHIJKLMNOPQRSTUV

ITC New Baskerville

Modern
This refined and more delicate style is characterized by high or dramatic contrast between the thick and thin strokes, curved strokes on a vertical axis, and serifs that are horizontal with little or no bracketing.

abcdefghijklmnopqrstuvwxyz
ABCDEFGHIJKLMNOPQRSTUVW

ITC Bodoni

Clarendon
This style made popular in the 1850s has a strong vertical weight stress, heavy, bracketed serifs which are usually square, and a slight stroke contrast.

abcdefghijklmnopqrstuvwxyz
ABCDEFGHIJKLMNOPQRSTUV

Clarendon

Slab or Square Serif
An early nineteenth-century style, these typefaces have very heavy square serifs, little or no bracketing, and hardly any stroke contrast, appearing monostroke. They are often geometric or square in style.

abcdefghijklmnopqrstuvwxyz
ABCDEFGHIJKLMNOPQRSTUVWX

ITC Lubalin Graph

Glyphic

Glyphic type styles are lapidary (carved or engraved) rather than pen-drawn in nature. They have a *vertical* axis, minimum stroke contrast, and often have triangular or flaring serifs.

ABCDEFGHIJKLMNOPQRSTUVWXYZ
ABCDEFGHIJKLMNOPQRSTUVWX

Copperplate

SANS SERIF

From the French word for "without," sans serif typefaces are without serifs. These were some of the first styles to be cut in stone and have had periodic returns to popularity due to their simplicity, as well as their somewhat industrial look. These are some of the most common categories of sans:

19th Century Grotesque

This style was the first popular sans. Its distinguishing features are contrast in stroke weight, a squared look to some curves, a "spurred" G and a double-bowl (also referred to as two-story) g.

abcdefghijklmnopqrstuvwxyz
ABCDEFGHIJKLMNOPQRSTUVWXYZ

News Gothic

20th Century Grotesque

This neo-grotesque style has less pronounced stroke contrast and is more refined in form than its predecessor. It has lost the squared curve and has a single-bowl g.

abcdefghijklmnopqrstuvwxyz
ABCDEFGHIJKLMNOPQRSTUVW

Univers

Geometric
These typefaces have strong geometric shapes, such as the perfect circle o, etc.
They usually have monotone strokes.

abcdefghijklmnopqrstuvwxyz
ABCDEFGHIJKLMNOPQRSTUVWXYZ

ITC Avant Garde Gothic

Humanistic
Humanistic type styles were an attempt to improve the readability of sans
serifs by applying a sans serif structure to the classical Roman form;
more simply, they are based on the proportions of Roman caps and old style
lowercase, with an apparent stroke contrast.

abcdefghijklmnopqrstuvwxyz
ABCDEFGHIJKLMNOPQRSTUVWX

Optima

SCRIPTS (AND BRUSH SCRIPTS)
These designs represent a large category of typefaces which are derived from
or imitate handwriting or calligraphy. They include a wide variety of styles and
characteristics, and are much more fluid than more traditional type styles.

abcdefghijklmnopqrstuvwxyz
ABCDEFGHIJKLMNOPQRS

Kuenstler Script

abcdefghijklmnopqrstuvwxyz
ABCDEFGHIJKLMNOPQRSTUVWXYZ

Mistral

DECORATIVE AND DISPLAY

This very broad category encompasses many hundreds of type styles that do not fit into any of the preceding categories, as they are designed primarily for headlines and meant to be distinctive, original and eye-catching. They adhere to few or no rules and constraints, and defy pigeonholing of any kind.

ABCDEFGHIJKLMNOPQRSTUVW
ABCDEFGHIJKLMNOPQRSTU

ITC Abaton

abcdefghijklmnopq
ABCDEFGHIJKLMNOPQ

ITC Freddo

abcdefghijklmnopqrstuvwxyz
ABCDEFGHIJKLMNOPQRSTUVWXYZ

Uncle Stinky

abcdefghijklmnopqrstuvwxyz
ABCDEFGHIJKLMNOPQRSTUVWXYZ

Suburban

abcdefghijklmnopqrʃtuvwxyz

ABCDEFGHIJKLMNOPQRʃTUVWXYZ

ITC Farmhaus

abcdefghijklmnopqrstuvwxyz

ABCDEFGHIJKLMNOPQRSTUVWXYZ

ITC Pious Henry

ITC Beesknees

abcdefghijklmnopqrstuvwxyz

ABCDEFGHIJKLMNOPQRSTUVWXYZ

Teknik

SELECTING THE RIGHT TYPE FOR THE JOB

Type has the power to make or break a job. Every typeface has a different personality, and the ability to convey different feelings and moods, some more than others. Display typefaces, also known as headline typefaces, tend to be stronger in personality, sometimes trading legibility at smaller sizes for a more powerful feeling. They can evoke strength, elegance, agitation, silliness, friendliness, scariness, and other moods. Text designs, often used for blocks of copy, are more subtle in mood and emphasize legibility and readability. Their personalities tend to be whispered, rather than shouted.

Although typeface selection is a very personal, subjective decision, there are some guidelines and unofficial rules that will help you narrow down your search and ultimately help you make the right choice.

DESIGN GOALS

The first and foremost step in selecting a typeface is knowing your goals. As a designer, your primary responsibility is to serve the client using your design and problem-solving skills. It is not to make their job into your own personal award-winning design statement. Personal self-expression to the exclusion of the needs of the project are what fine art is all about, but not graphic design.

Every job requires a different approach. An annual report might call for a typeface with a high degree of legibility that also captures the spirit of the company, but a book cover might

Arriba arriba

RETRO BOLD

ITC Clover

ITC Jambalaya

ITC Schizoid

Fette Fraktur

Jazz

ITC Vintage

ITC Ziggy

Every typeface has its own personality and ability to convey different moods and feelings, some more than others. Display typefaces tend to be stronger in personality, sometimes trading legibility at smaller sizes for a more powerful feeling.

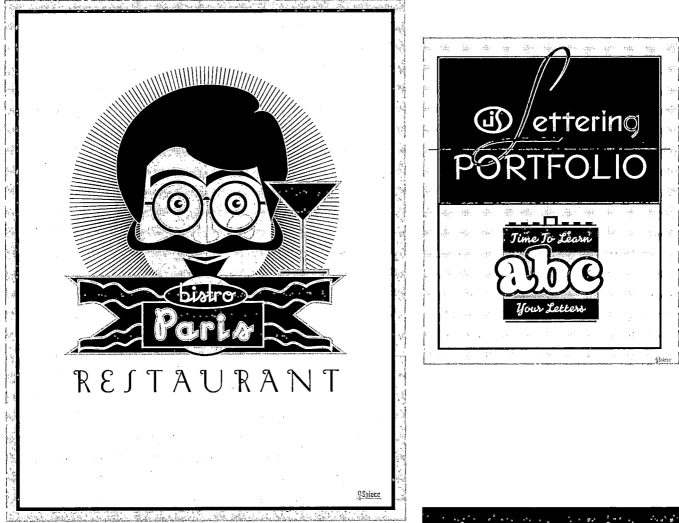

These portfolio pieces by Jim Spiece combine expressive typography with illustration to convey a very inviting French culinary experience (l.) and childlike whimsy (r.).

The typeface used on this book cover designed by Richard Fahey screams out excitement, danger and intrigue in conjunction with the illustration. Book covers need to capture one's attention quickly amidst a sea of other books, and this one makes its point in a strong way.

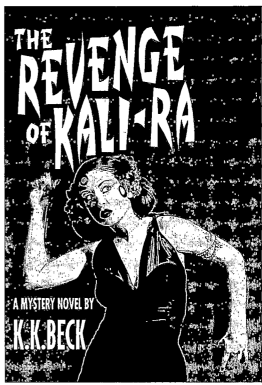

need a face that catches the eye and tells a story in a split second amidst a sea of other books. A travel brochure might need to evoke the excitement and flavor of a foreign country, while a text book or novel might call for a pleasing, readable text face that doesn't tire the eyes after long lengths of copy.

To focus your design goals and subsequently the most appropriate typefaces to use, start by identifying the age, attention span and demographics of your audience. Different typefaces attract a different audience, both subliminally and overtly. Children are drawn to easy-to-read, childlike fonts; seniors to larger settings that have more clarity and legibility; teens to more edgy, expressive designs. After you consider your audience, ask yourself how much reading you are asking them to do, and what information you are expecting them to walk away with. Once you identify your design objective, you will narrow down your typeface choices considerably.

Gill Sans
Optima
ITC Century
News Gothic
ITC Stone Serif
Minion
Schneidler
ITC Officina Sans
ITC Legacy Serif

Counters, x-height, character shapes, stroke contrast, etc., all contribute to the legibility of a typeface. These text faces are extremely legible due to their clean, consistent, uncomplicated design features, which make it easy to distinguish one letter from another.

These display designs forgo a high degree of legibility for a stronger personality, elaborate and more expressive shapes, and a more distinctive look. When the objective is to be instantly noticeable and convey a certain mood or feeling, extreme legibility might not be a priority.

LEGIBILITY AND READABLILTY

One often hears type described as being legible and/or readable. Although they both relate to the ease and clarity with which one reads type, they actually refer to two different things: legibility refers to the actual typeface, while readability refers to typography, or how the typeface is set.

The legibility of a typeface is related to the characteristics inherent in its design including the size of its counters, x-height, character shapes, stroke contrast, serifs or lack thereof, and weight, all of which relate to the ability to distinguish one letter from another. Not all typefaces are designed to be legible. This is more of a consideration for text designs where the degree of legibility relates directly to holding the reader's attention for the duration of the copy. Display designs are generally used for a few words in larger settings where the objective is to be instantly noticeable and to convey a mood or a feeling, so legibility might not be as important.

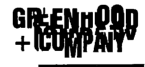

This logo for Greenhood + Company created by Vrontikis Design Office trades slickness and readability for an intentional low-tech look, which is in direct opposition to what you would expect from a company specializing in new media and technology. Typographic irony can be a powerful tool.

The next unpleasant business was putting on the iron shoes; that too was very hard at first. My master went with me to the smith's forge, to see that I was not hurt or got any fright. The blacksmith took my feet in his hand, one after the other, and cut away some of the hoof. It did not pain me, so I stood still on three legs till he had done them all.

The next unpleasant business was putting on the iron shoes; that too was very hard at first. My master went with me to the smith's forge, to see that I was not hurt or got any fright. The blacksmith took my feet in his hand, one after the other, and cut away some of the hoof. It did not pain me, so I stood still on three legs till he had done them all.

Readability is related to how you arrange the type and is affected by size, leading, line length, alignment, letter spacing and word spacing. Even a legible typeface, like ITC Flora, can lose readability when set 14/15. But its readability improves dramatically when set 12/18. (Black Beauty)

Readability is related to how you arrange the type. Factors affecting type's readability include size, leading, line length, alignment, letter spacing and word spacing. So it follows that a legible typeface can be made unreadable by how it is set, while a typeface with poor legibility can be made more readable with these same considerations.

In choosing a typeface, consider its legibility and how important that is to your design objective, but once chosen, it is up to you to enhance its readability.

TEXT VS. DISPLAY

There are two main categories of type: text and display. Simply put, text type is designed to be legible and readable at small sizes. This usually implies fairly clean, consistent, uncomplicated design features, more open spacing than a display face, and thin strokes that hold up at smaller sizes. Display type, on the other hand, can forgo the extreme legibility and readability needed for long blocks of text at small sizes for a stronger personality, elaborate and more expressive shapes, and a more stylish look.

Many typefaces do not adhere to these descriptions, however, and can be used for both text and display. Some even look their best at midrange sizes. So when you are choosing a font, try to see a word grouping set at a size close to what you will be using. It is very difficult to visualize what 14-point text will look like from a 60-point "a–z" showing.

SCRIPT, CALLIGRAPHIC AND HANDWRITING FONTS

Script and calligraphic fonts are in a class of their own and can overlap both text and display categories. They can be very elegant, formal and classy, or very humanistic, quirky and quite individualistic. Scripts and calligraphics are often used for invitations, announcements, headlines and initial letters; handwriting fonts are great for informal correspondence as well as ads and brochures requiring a more personal, informal look.

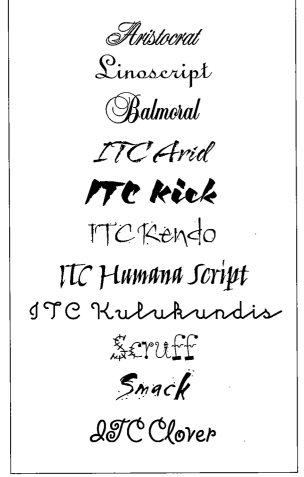

These script, calligraphic and handwriting-inspired typefaces can be very elegant, formal and classy, or be humanistic, quirky and quite individualistic. They are fun to use, but use them with caution as they make a very strong—sometimes too strong—graphic statement.

Combining Rougfhouse, a "sick" looking display typeface, with Scala Sans makes the message come alive in this promo piece by SVP Partners. It appeared on airline-style "sickie" bags as well as t-shirts.

An elegant type treatment for a Mohawk Paper promo by VSA Partners, Inc. A clean, tasteful design results from contrasting script with serif typeface, large with small, cap with lowercase, and black with color.

The number of fonts in these categories has swelled tremendously in the last several years due to their popularity with both designers and neophytes. Before making your selection, look the fonts over carefully for the legibility of both the caps and lowercase, as well as their appropriateness for your job. These fonts are fun to use, but use them with caution, as they make a very strong graphic statement that can either go a long way toward communicating your message or stop your audience cold.

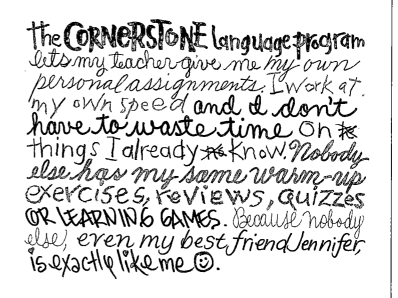

These three pieces by hand-letterer Jill Bell could never have been done on a computer with fonts—their warmth and individuality require the design sensibilities, skill and talent of a human being.

The hand-tailored scripts and lettering in these three examples coupled with the decorative flourishes and elaborate, yet tasteful, border could never be created from fonts. Once again, it takes a skillful letterer such as Gerard Huerta to pull this off.

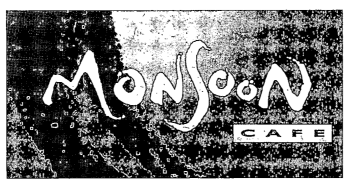

This hand-lettered logo for Monsoon Café, drawn by Christina Hsaio for Vrontikis Design Office, captures the essence of the "lands of the monsoon." Every character was drawn to work with those around it; each of the three "o"s is a different design, which would have been impossible with a typeface.

These three colorful letters say it all in this very simple yet eye-catching invitation by SVP Partners.

RENEWING THE STRENGTH WITHIN.

Leaving welfare and poverty is not an event. It's a process. The Women's Resource Center focuses on moving women out of crisis and toward employability. We help women develop new job skills. We arrange Career Development Services seminars. Provide mentoring and wardrobe assistance. And help ensure greater success with support services such as good child care, transportation, and a safe place to live. Overall, the center served 4,300 women in 1998. Of those we have placed in jobs, 90% are still employed.

The use of ITC Deelirious, a quirky yet charming hand-writing font designed by Dee Densmore D'Amico to head up a sans serif text treatment, gives warmth and a personal feeling to this YWCA brochure designed by Buck & Pulleyn, Inc.

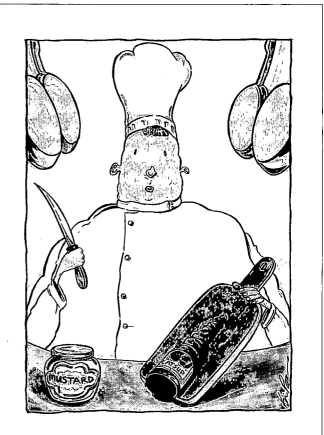

Monroe could slice the catsup, but he just couldn't cut the mustard.

No typeface would have worked as well as this hand-lettered type by Kevin Pope, who also did the illustration for this Yupo promo piece by SVP Partners; they work together as one.

Some jobs require the kind of typographic treatment and interpretation that cannot be achieved with an existing font. No matter how many typefaces you look at, none of them seem to do what you want them to do. Don't panic—at times like these the unique talents and skills of a hand-letterer or a calligrapher should be seriously considered. The work they do is very specialized and unique and is custom-designed to your exact needs. They can create as little as a one-word logo or an entire alphabet for an ad campaign. In a world containing thousands of typefaces, the work and artistry of hand-letterers and calligraphers is invaluable, and it will continue to be an important resource for the design community.

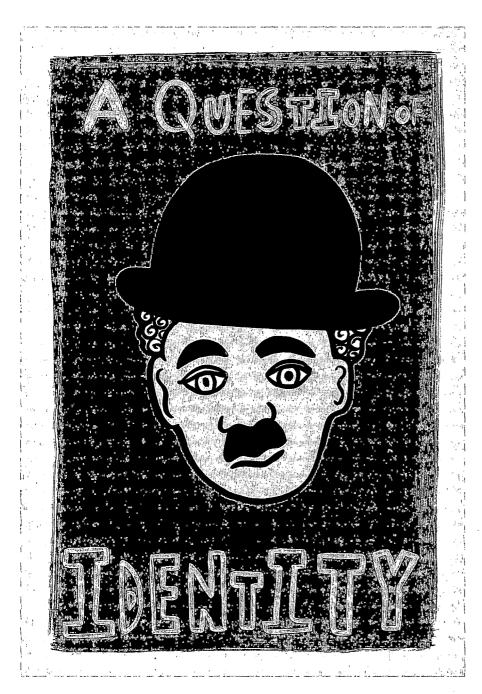

A very different example of where the best typeface for the job might not be a typeface at all. This piece for Mohawk Paper Mills designed by Rigsby Design addresses the question of "identity" by using a rather crude, inconsistent yet surprisingly rhythmic handwriting throughout the piece, sending a very low-tech, personal message. It works great with the illustration.

TYPE FAMILIES

Special consideration should be given to using type families. These are usually text or text/display families with corresponding sans, serif and sometimes informal or script versions. They usually have the same basic structure but with different finishing details, enabling them to work well together.

 This is a very safe yet effective way to mix typefaces while keeping your job looking clean and not over-designed. Type families have even more mileage if they are available with small caps, which give you another option to create emphasis without jarring the reader and disturbing the flow too much.

ITC Bodoni Six

Book w/ Oldstyle & SMALL CAPS

Book Italic w/ Oldstyle

Bold w/ Oldstyle

Bold Italic w/ Oldstyle

ITC Bodoni Twelve

Book w/ Oldstyle & SMALL CAPS

Book Italic w/ Oldstyle

Bold w/ Oldstyle

Bold Italic w/ Oldstyle

ITC Bodoni Seventy-Two

Book w/ Oldstyle & SMALL CAPS

Book Italic w/ Oldstyle & Swash

Bold w/ Oldstyle

Bold Italic w/ Oldstyle & Swash

ITC Bodoni Ornaments

ITC Bodoni Six, Twelve and Seventy-Two are authentic revivals of Giambattista Bodoni's original designs. These classic yet practical size-sensitive designs are an unusual concept in digital fonts. There are Swashes for the Seventy-Two Italics, and several Bodoni ornaments in each font as well as many more in a font of their own, making this a very versatile family.

ITC Stone Serif

Regular & *Italic*
Semibold & ***Semibold Italic***
Bold & ***Bold Italic***

ITC Stone Sans

Regular & *Italic*
Semibold & ***Semibold Italic***
Bold & ***Bold Italic***

ITC Stone Informal

Regular & *Italic*
Semibold & ***Semibold Italic***
Bold & ***Bold Italic***

The ITC Stone type family consists of serif, sans and informal versions in three weights with Italics. It is an extremely legible, practical and versatile text family with lots of mixing possibilities.

ITC Humana Serif

Light *& Light Italic*
Medium *& Medium Italic*
Bold *& **Bold Italic***

ITC Humana Sans

Light & *Light Italic*
Medium & *Medium Italic*
Bold & ***Bold Italic***

ITC Humana Script

Light
Medium
Bold

ITC Humana is unusual in that it is a calligraphic–based type family having both text and display applications. The serif and sans versions are warm, lively and humanistic as the name suggests, as well as being quite legible at small sizes. The script version is a very strong, dramatic, condensed calligraphic design which can be used at larger sizes in conjunction with the serif and sans.

Triplex

Light
Bold
Extra Bold

Triplex Serif

Light
Bold
Extra Bold

Triplex Condensed

Regular
Black

Triplex Condensed Serif

Regular
Black

Emigre Triplex is a stylish type family consisting of sans and serif Roman (upright) designs as well as condensed versions. They should be treated as separate designs and used together very carefully; although they have the same roots, their width differences make them more challenging to use together effectively.

DOS AND DON'TS

Here are some suggestions and points to consider when choosing and using a typeface:

■ **Do** start with a few basic typefaces and type families, and learn how to use them well. Consider them the backbone of your typographic wardrobe—then you can add to them to fit more specific occasions. Many excellent designers use the same menu of typefaces for most of their jobs, and used appropriately, they always manage to look fresh and do the job well.

■ **Do** leave white space. That old adage "less is more" often applies to type and design. No need to fill up every square inch of space—in fact, white space can create drama and emphasize the type.

■ **Do** consider production issues when selecting text type. For instance, when going very small, watch out for disappearing thin strokes, especially when printed.

This typeface should not be set too small or the thins might break up when printed.

This typeface should not be set too small or the thins might break up when printed.

Caslon Openface with its delicate thin strokes is a perfect example of a type-face that looks great at 20 point, but becomes more difficult to read at 12 point. It also becomes a challenge to print without the thins breaking up in the process.

■ **Do** consider how your type will look at the size you are planning to use it. For instance, when using a thick/thin script (or any high-contrast typeface) for a headline, make sure it doesn't look too clunky at large sizes. What looks great at 18 point might look too heavy and lose its elegance at 96 point.

■ **Don't** go too big when setting text; smaller with more leading is often more readable than a larger setting with tight leading.

■ **Don't** set to fit. Decide on a point size that looks and reads the best, and adjust leading and line width (or the length of your copy if possible) accordingly.

■ **Don't** tint type with delicate thins. It might break up when printed.

■ **Don't** distort your type with the features available in your page-layout program. Type that has been electronically expanded, slanted, emboldened and condensed looks very amateurish and is annoying to the eye.

■ **Don't** let the way a typeface looks on a laser proof be the deciding factor in your selection, as it can look much heavier than the actual printed piece. There has been many an unhappy client when the type on a very expensive invitation is too light or has broken up on the printed piece.

MIXING IT UP

A common query when designing with type is "How can I mix type?" or, more specifically, "How can I mix type effectively?" When choosing a type-face outside the primary family you are using, there are three things to remember: *contrast, contrast* and *contrast*. A common mistake is to use two or more faces which are too close in style, making the change not noticeable enough to serve the purpose at hand, yet creating a subtle disturbance which detracts from the cohesiveness of your design. Combine typefaces when you want to emphasize or separate a thought, phrase or text visually. The eye needs to see distinct differences for this to be achieved effectively. These basic principles should keep you on the right track:

Serif vs. Sans: A good rule of thumb when combining type is to mix a serif and a sans. There are usually strong design differences between them (unless they are part of a type family) which can achieve the contrast you are looking for.

Light vs. Heavy: Using a heavier (or lighter) weight typeface creates a strong visual contrast. This technique is often used for subheads; using a heavy sans, perhaps all caps, within a body of serif text does the trick very well.

 NOTE: Make sure you go heavy enough because using the next weight up (e.g., book to medium) often results in a weak visual transition.

Large vs. Small: A good place to change fonts is when type changes size, such as from headline to subhead or text. The distinction will be emphasized that much more.

Three typefaces: a script, a sans and a serif work together beautifully in this small but simple and cleanly designed self-promotion piece by Stephen Banham of The Letterbox.

Wide vs. Narrow (or *Regular vs. Condensed*): An expanded head-line font above an average-width body text, or a logo split in two using this technique can create a very powerful contrast.

Cap vs. Lowercase: Another way to get more mileage out of changing fonts is to use all caps for one of the settings, particu-larly if it is short; but stay away from setting lengthy text in all caps, as it dramatically reduces readability. We read words by their shapes, not by individual letters, and all-cap settings elimi-nate the information (ascenders and descenders) our brains need to read most easily.

Combine nine different typefaces on one page and get away with it? Deanne Lowe does it, and very successfully in this U&lc table of contents. The different typestyles add visual excitement and inter-est to an otherwise simple page.

U&lc Volume 26, Number 2, Fall 1999

4

This book cover designed by Andrew Newman mix typefaces in a way that suggests the "gender" differences referred to in its title. Book covers need to get the message across by their look as well as their words. "Men..." is set in Arquitectura and "Women..." is set in Centaur (modified).

This text treatment, as part of a promo piece designed by SVP Partners, uses two different sans serif typefaces, but they are different enough to work well together. Suburban, the quirky typeface used for the text, maintains its read-ability in spite of its small point size and reverse treatment.

MEN ARE
FROM MARS,
Women Are
from Venus
A Practical Guide for
Improving Communication and
Getting What You Want in Your Relationships
JOHN GRAY, Ph.D.

An effective use of width contrast in the two sans typefaces used for this book cover designed by Marty Blake (l.). Setting the wider face, Eagle Bold, in all caps distinguished it even more from its condensed companion, Binner Gothic. Below, Marty Blake combines ITC Bodoni Seventy-Two, a historic serif typeface, with Engravers Gothic, as well as using size and case contrast (upper and lowercase vs. caps) on this book cover to stimulate a renewed interest in a historical document.

The dramatic type treatment of the word "HATE" might look hand-lettered, but it actually is a typeface called Carnival. It acts as a kind of typographic illustration in that its powerful appearance evokes the feeling of what it says. (Designed by Andrew Newman.)

BASIC TECHNIQUES
FOR EMPHASIS

B efore the written word came into being, speech was the primary form of communication. Over the centuries it has evolved into many languages, each with its own individual ability to express hundreds of thoughts and feelings through a unique vocabulary, as well as many nuances of sounds and pronunciation.

When we speak, we communicate our message both verbally and non-verbally. Some of the verbal techniques include the tone and inflection of our voice, the volume of our speech in general or of particular words and phrases, the speed at which we speak and say certain words, as well as pauses. Nonverbal communication consists of facial expressions, including movement of the eyes and surrounding muscles, the mouth and lips; the tilt of the head and neck; hand, arm and shoulder movements; body posture and total body movement. We often don't realize how much of what we communicate and what we hear and perceive from others is relayed this way.

When communication takes the form of the printed word, none of the above techniques can be directly applied to conveying a message to your audience. In their place, however, there are many typographic techniques which can be used to make up for these missing elements and communicate your message in the most effective way possible. The written word expressed typographically is a rich and wonderful world all its own.

Many of these typographic techniques have evolved over the years, and vary from designer to designer and sometimes from country to country. If you are not familiar with them, use them selectively and sparingly at first until you become more comfortable with them. If you place too many emphasizing techniques in too many places, it will defeat the purpose of making certain elements stand out from the rest and dilute the overall effectiveness of your message, making for a visually busy piece.

The millennium is now!

The millennium is now!

True-drawn italics are usually a unique and separate design from their companion Roman with differing design features and character widths, and often appearing somewhat calligraphic in nature. ITC Galliard Roman and Italic are a perfect example of this.

The millennium is now!

The millennium is now!

ITC Avant Garde Gothic Medium Oblique is a slanted version of its Roman companion with few or no design changes. Obliques are used in much the same way as italics although they create less contrast.

ITALICS

The use of italics is probably the most common form of typographic emphasis and is used in both text and display settings. *True-drawn italics* are an angled typeface most commonly designed as a companion to a Roman (straight up and down) design. They are usually a unique and separate design from their companion Roman with differing design features and character widths and often appearing somewhat calligraphic in nature. *Obliques* are slanted versions of their Roman companion with few or no design changes. They are used in much the same way as italics although they create much less contrast. Some italic designs will stand out more than others from their companion Romans, so keep this in mind when choosing a typeface for a job needing a highly contrasting italic.

Italics are most effectively used for soft emphasis of words or phrases within a headline or text–that is, they draw the reader's attention without a significant change in the color of the text. Italics are also used instead of quotations for book and magazine titles and the like. Be sure to use the same weight italic as the Roman you are using and not the next weight up; if a double emphasis is desired, you might want to jump two weights to create a more noticeable effect.

Avoid italicizing and embolding from your style menu.

Avoid italicizing and embolding from your style menu.

Avoid italicizing and embolding from your style menu.

Avoid italicizing and embolding from your style menu.

Avoid italicizing and embolding from your style menu.

Avoid italicizing and embolding from your style menu.

Italic and bold versions of a typeface should not be created using the style bar. To be assured of their authenticity, true-drawn italic and bold versions of the actual typeface should be accessed through the font menu. Computer-generated versions are extremely inferior and should be avoided at all costs. This showing of ITC Stone Serif demonstrates how the computer-generated versions on the top are inferior in design, width and spacing to the true-drawn originals on the bottom.

Obliques and italics (as well as other font variations) should be accessed from your font menu if possible and not from your style bar. Some manufacturers link true-drawn italics to their Roman counterparts via the style bar function, but others don't. In these instances, and where italics aren't available, computer-generated italics are created on the fly. These should be avoided at all costs, as this process distorts character shapes in a way that degrades the design and metrics of the typeface and is annoying to the eye. As mentioned above, true-drawn italics are usually a completely different design, and true-drawn obliques are adjusted for any distortion. Use of computer-generated variants is a sign of a real amateur.

BOLDFACE (OR WEIGHT CONTRAST)

The use of boldface, or a bold version of a lighter weight, is a good way to achieve emphasis by way of weight contrast. It is best used for subheads, captions and stand-alone words and phrases. It should be used sparingly within text and only in particular instances where a strong emphasis is desired because it creates a somewhat harsh visual interruption in the color. When using a boldface from a family of several weights, it is usually best to jump at least two weights to create a strong enough contrast; a too-small weight contrast at the same point size is at best ineffective and at worst, amateurish typography. (Once again, avoid using computer-generated embolding from your style bar as it is a poor imitation of a true-drawn version and results in bad weight contrasts and metrics.)

Art is worthy of respect
Art is worthy of respect

Art is worthy of respect
Art is worthy of respect

Jump at least two weights to create a strong contrast when using a boldface from a family of several weights. A too-small weight contrast at the same point size is at best ineffective and at worst, amateurish typography.

UNDERSCORES

Underscores are a poor typographic method to achieve emphasis and should seldom be used. They are a holdover from typewriter days when this was the only way to highlight text. Most underscores created in word-processing programs (as well as automatic underscores in design programs) cannot be adjusted for weight and position and usually crash through the descenders. If you must use them, create them in

<u>Frequent flyers</u>
<u>Home team wins!</u>

<u>Frequent flyers</u>
<u>Home team wins!</u>

Underscores created in word-processing programs (as well as automatic underscores in design programs) cannot be adjusted for weight and position and usually crash through the descenders. If you must use them, create them in design programs with the drawing/pencil tool so that you can adjust the thickness and the position.

design programs with the drawing/pencil tool so that you can adjust the thickness and the position, remembering to keep them consistent throughout your piece.

There are exceptions to these rules as there are to any rules. Some designers will use underscores as a conscious design element. In fact, sometimes the underscore is exaggerated and is extended underneath lines of copy or actually runs through it to achieve a particular look. If this is the effect you are going for, of course go ahead and experiment, but it then becomes part of the style and personality of your design, and not a tool for emphasis within text.

NOTE: The use of an underscore on the Web has an entirely different function, usually implying a hyperlink.

POINT SIZE

Varying the point size of your type for emphasis is a technique that should be used very sparingly, particularly within text. It is best reserved for subheads and other stand-alone phrases and should not be used within text unless an extreme emphasis is desired as it disturbs the color, texture and flow.

This ad by SVP Partners uses a multitude of type sizes to "help" the reader with the headline and, more importantly, make a very powerful typographic statement.

I wish I hadn't cried so much!' said Alice, as she swam about, trying to find her way out.'I shall be punished for it now, I suppose, by being drowned in my own tears! That **will** be a queer thing, to be sure! However, everything is queer today.'

Changing the point size of words or phrases in text for emphasis is a poor choice; the use of italics or some of the other methods mentioned are usually preferable. (Alice in Wonderland)

More than **80%**

of sales come from brands that are #1 or #2 in their markets.

With our broad-based brand power... consumer marketing know-how... cutting-edge innovation...tremendous financial strength...and a focused strategy...our 26,000 associates are delivering excellent growth.

TO OUR SHAREHOLDERS

but the results are well worth the effort. Survival demands extraordinary tenacity and talent, superior resources, some luck, and strength of heart. Success in making the passage assures that we will continue to thrive and prosper. For the new Citizens, blessed with great growth potential, depth of strong management and an unmatched portfolio of assets, evolution assures a continuum of evergreen opportunity.

These two pieces, also by SVP Partners, use scale and color to create exciting and effective graphics in a purely typographic environment. The piece above blows up an important numerical element, balancing the copy to its right. The piece on the left makes a headline out of the lead-in to the first sentence, drawing the reader in.

A change of point size, color and alignment of select words draws the viewer in and through the copy in this piece by Hornall Anderson Design Works, Inc.

He shall from time to time give to the Congress Information of the State of the Union, and recommend to their Consideration such Measures as he shall judge necessary and expedient; he may, on extraordinary Occasions, convene both Houses, or either of them, and in Case of Disagreement between them, with Respect to the Time of Adjournment, he may adjourn them to such Time as he shall think proper; he shall receive Ambassadors and other public Ministers; he shall take Care that the Laws be faithfully executed, and shall Commission all the Officers of the United States.

The President, Vice President and all civil Officers of the United States, shall be removed from Office on Impeachment for, and Conviction of, Treason, Bribery, or other high Crimes and Misdemeanors.

A very innovative promo piece by Doyle Partners which uses scale, color and a layered design to make the U.S. Constitution visually exciting.

PASSION

CAP VS. LOWERCASE

Setting a word or phrase in all caps for soft emphasis is generally a poor choice, as the jarring change in cap height, while drawing attention to itself, interrupts the text in an aesthetically poor manner. Once again, it disturbs the rhythm and flow of the text. Conversely, if a strong emphasis is desired, as in the case of important call-out words or phrases, it can be very useful if utilized sparingly and very intentionally as it creates a very noticeable emphasis. All caps should be used only for very important words or phrases that are discussed or referred to at length in the text. Use with discretion.

A similar but preferable method would be to use small caps if they are available in the font you are using, because they blend in better with the lowercase. (Try to stick to true-drawn small caps, as reduced caps will be too light and not match the color of the text.)

WIDE VS. NARROW

The use of width contrast in related or unrelated typefaces should be avoided as a technique for emphasis in body text, as it creates too much of a contrast and interrupts the flow in a jarring way. On the other hand, it can be used effectively in headlines, subheads, leaders and the like to create contrast.

CHANGING TYPESTYLE

The use of a totally different typeface to emphasize words in a text block should be avoided unless a very strong emphasis is desired, as it is much too harsh a change. On the other hand, it can be very effective in subheads, callout quotes and the like. Stick to the use of italics or boldface for emphasis within text.

CHANGING COLOR OR SHADE

Changing the color of type can be used in certain instances to create visual excitement and variety while drawing the eye to certain points. It should not be used in body text unless a very strong emphasis is needed for specific words or definitions which are essential to understanding the content. Changing the percentage of your primary color to a tint can also be used when a softer technique is preferred, as this creates less of a disturbance in the color and the texture of the type. Just be sure that there are no thin strokes that might break up when tinted.

Romeo, *away be gone:*
The Citizens are up,
and Tybalt slaine,
Stand not amaz'd, the Prince
will Doome thee death
If thou art taken: hence,
be gone, away.

Romeo, **away be gone:**
The Citizens are up,
and Tybalt slaine,
Stand not amaz'd, the Prince
will Doome thee death
If thou art taken: hence,
be gone, away.

Romeo, AWAY BE GONE:
The Citizens are up,
and Tybalt slaine,
Stand not amaz'd, the Prince
will Doome thee death
If thou art taken: hence,
BE GONE, AWAY.

Romeo, AWAY BE GONE:
The Citizens are up,
and Tybalt slaine,
Stand not amaz'd, the Prince
will Doome thee death
If thou art taken: hence,
BE GONE, AWAY.

This example demonstrates the use of italics, boldface, all caps and small caps as emphasis techniques. Which do you think works best to draw attention to the words in question in a subtle yet effective way? (Romeo and Juliet)

This excerpt from chapter four illustrates an appropriate context in which to use a change of typeface, weight and color for a strong emphasis. When doing this, you might have to adjust point sizes slightly to get the x-heights to match up. In this case, the bold sans words are a half point smaller than the rest of the text.

'Oh, *please* mind what you're doing!' cried Alice, jumping up and down in an agony of terror. 'Oh, there goes his *precious* nose'; as an unusually large saucepan flew close by it, and very nearly carried it off.

'Oh, please mind what you're doing!' cried Alice, jumping up and down in an agony of terror. 'Oh, there goes his precious nose'; as an unusually large saucepan flew close by it, and very nearly carried it off.

'Oh, **please** mind what you're doing!' cried Alice, jumping up and down in an agony of terror. 'Oh, there goes his **precious** nose'; as an unusually large saucepan flew close by it, and very nearly carried it off.

'Oh, please mind what you're doing!' cried Alice, jumping up and down in an agony of terror. 'Oh, there goes his precious nose'; as an unusually large saucepan flew close by it, and very nearly carried it off.

Several other techniques for emphasis are illustrated here. The use of italics in the first paragraph is commonly used and is very effective in most instances. The second paragraph uses a condensed version of the typeface and is awkward and barely noticeable when scanned by the reader's eye. The third tries a change of typeface which creates too strong a change for the context. The last uses a change of color; it is too much emphasis for this purpose, but can be very effective in other instances, such as the example below. (Alice in Wonderland)

DOs and DON'Ts

Here are some suggestions and points to consider when choosing and using a typeface:

- **Do** start with a few basic typefaces and families.
- **Do** leave white space.
- **Do** consider production issues.
- **Don't** go too big when setting text.
- **Don't** set to fit.
- **Don't** tint type with delicate thins.

ADVANCED TECHNIQUES FOR EMPHASIS

sing italics, boldface or color to create diversity throughout your text is a fine way of emphasizing the point. More sophisticated techniques exist for the designer who chooses to go beyond the basics, and these simple yet rich and elegant variations can bring a whole new flavor to a text-heavy page when used tastefully and effectively.

INITIAL CAPS

An initial cap (or letter) is an enlarged character, usually the beginning letter of the first sentence of a paragraph, which is set in a decorative or graphic way. It can liven up a page and add typographic interest to an otherwise dull and boring page or section. Initial caps can be a different weight or style of the typeface in use, or a completely different font. Highly contrasting weights and styles, as well as elaborate, decorative, calligraphic or ornate type styles in contrasting colors and tints are often used and can work well.

Proper alignment on all sides is key to using initials tastefully and professionally. If the initial cap is meant to appear flush left, align it optically rather than mechanically. Certain characters, including rounds and diagonals, as well as characters with serifs that get proportionally larger with size, will need to be pulled out a bit to appear visually aligned and balanced.

NOTE: You will have more flexibility if you put the initial in a separate text box from the rest of the word so that you can manipulate it independently. The Initial Cap option in most programs won't allow you to make fine adjustments.

These are some of the more common styles of initial caps:

Drop cap–When a character begins at and drops below the first line of text, it is referred to as a drop cap. Drop caps usually optically align (different from mechanical alignment) with the cap height of the first line and should base-align with a line of type below. Dropping into an odd number of lines is most tasteful and pleasing; go at least three lines deep.

Body copy can be wrapped around the initial if the character is large and uncomplicated enough to keep it visually clean. To help the initial read as part of the first word, tuck in the remaining characters of the word closer to the initial even if it extends out of the text margin.

Message *from* ITC

IN OCTOBER, ITC WENT TO England & France. In London, we hosted a launch party at the St. Bride Printing Library for an ambitious new type family, ITC Founder's Caslon – a direct revival by Justin Howes of William Caslon's type designs from the 18th century. In Lyon, we participated in the 1998 conference of the Association Typographique Internationale (ATypI), typography's premier international gathering of professional practitioners.

In England we were celebrating the first typeface family to bring the quirks & subtleties of Caslon's distinct & various type sizes into the digital realm. In France we were celebrating the myriad ways in which typography can be approached, in distinct languages and cultures, in a variety of unpredictable technologies, and in the quirks & subtleties of the people who make up the typographic world.

– Mark Batty, President

Mark van Bronkhorst goes to exciting extremes with this colorful drop cap, which creates a strong vertical element to a very horizontal message in U&lc. Notice the small caps leading into the body of the text.

Once more she found herself in the long hall, and close to the little glass table. 'Now, I'll manage better this time,' she said to herself, and began by taking the little golden key, and unlocking the door that led into the garden.

To help a drop-cap initial read as part of the first word, tuck in the remaining characters of the word closer to the initial even if it extends out of the text indent's left margin. (Alice in Wonderland)

First came ten soldiers carrying clubs; these were all shaped like the three gardeners, oblong and flat, with their hands and feet at the corners: next the ten courtiers; these were ornamented all over with diamonds, and walked two and two, as the soldiers did.

This drop cap aligns with the cap height of the text and base-aligns with the third line of type. The serifs overhang the left margin so the stem of the character aligns with the text below. (Alice in Wonderland)

Raised cap (also called *stick-up cap*) – A raised cap is one which base-aligns with the first line of type and rises above the body copy. It is much less complicated to do tastefully than a drop cap. If the raised cap is the first letter of a word (as opposed to a single-letter word such as "A" or "I"), make sure you space the rest of the word close enough to the initial to read as a word. The type looks very amateurish, not to mention being hard to read, when the rest of the word seems to be floating away.

She had not gone much farther before she came in sight of the house of the March Hare: she thought it must be the right house, because the chimneys were shaped like ears and the roof was thatched with fur. It was so large a house, that she did not like to go nearer till she had nibbled some more of the lefthand bit of mushroom, and raised herself to about two feet high: even then she walked up towards it rather timidly, saying to herself. 'Suppose it should be raving mad after all! I almost wish I'd gone to see the Hatter instead!'

Body copy can be contoured or wrapped around an initial if the character is large and uncomplicated enough to keep it visually clean. (Alice in Wonderland)

First came ten soldiers carrying clubs; these were all shaped like the three gardeners, oblong and flat, with their hands and feet at the corners: next the ten courtiers; these were ornamented all over with diamonds, and walked two and two, as the soldiers did.

This raised cap base-aligns with the first line of type and rises above the body copy. If the initial is the first letter of a word as opposed to a single-letter word, tuck in the remaining letters close enough so that it reads as a word. (Alice in Wonderland)

A New Graphic Identity

TO PROCLAIM THE MUSEUM'S MISSION AS THE NATIONAL ADVOCATE FOR DESIGN INTO THE TWENTY-FIRST CENTURY, A NEW VISUAL IDENTITY IS BEING DEVELOPED BY THE GRAPHIC DESIGN FIRM DRENTTEL DOYLE PARTNERS. The first phase of the project, implemented this fall, encompasses our logo, stationery, publications, and temporary fence signage. The second phase will yield a system of interior and exterior signage designed to unite the Museum's renovated, accessible facilities with the surrounding city. The Museum is introduc-

A dramatic raised cap sits atop the opening paragraph denoting an important announcement in this piece designed by Doyle Partners.

Decorative initials–Sometimes a very unusual, elaborate or ornate initial is appropriate and can do a lot to enhance a design, especially if color is an option as well. Some fonts are designed primarily for this purpose. In addition, some very interesting and unusual initials are available not as fonts but as EPS files, or picture files. They are worth looking into, especially if your job is text-based with few or no illustrations or photos and needs livening up.

A typeface with elaborate swashes or calligraphic forms can also add grace and visual interest to an otherwise dull design, as long as the letterform is appropriate to the content.

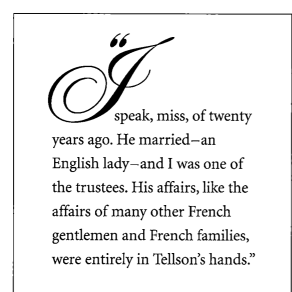

"I speak, miss, of twenty years ago. He married–an English lady–and I was one of the trustees. His affairs, like the affairs of many other French gentlemen and French families, were entirely in Tellson's hands."

A graceful and elaborate script initial such as this one set in ITC Edwardian Script designed by Ed Benguiat makes a very dramatic statement. The opening quotes are set smaller than the initial and are kerned and positioned so they don't float in the margin. (A Tale of Two Cities)

even flung down his brush, and had just begun 'Well, of all the unjust things–' when his eye chanced to fall upon Alice, as she stood watching them, and he checked himself suddenly: the others looked round also, and all of them bowed low.

This decorative initial is part of an initial font that comes with ITC Kendo. (Alice in Wonderland)

Boxed, reverse, overlapped initials—There are other techniques to add visual interest and originality to initial characters. The initial can be contained within an outlined box and tints or colors can be added if desired. Or you can set the initial in reverse, dropping it out of a box of black or any solid color. Another interesting approach is to make a rather large initial a light tint of black or a color and insert it partially behind the body copy. Just remember that whatever you do, readability should never be sacrificed. Your imagination is the limit to what you can do with initial characters; just remember to keep them tasteful and appropriate to the content and the rest of the design.

aLICE was beginning to get very tired of sitting by her sister on the bank, and of having nothing to do: once or twice she had peeped into the book her sister was reading, but it had no pictures or conversations in it, 'and what is the use of a book,' thought Alice 'without pictures or conversation?'

A lowercase letter can be used as an initial as well as a cap. Using small caps can be a very effective way to lead into the rest of the text. (Alice in Wonderland)

She had not gone much farther before she came in sight of the house of the March Hare: she thought it must be the right house, because the chimneys were shaped like ears and the roof was thatched with fur.

Initials can be placed in outlined, tinted boxes...
(Alice in Wonderland)

he had not gone much farther before she came in sight of the house of the March Hare: she thought it must be the right house, because the chimneys were shaped like ears and the roof was thatched with fur.

...or tinted and positioned behind text. Your imagination is the limit as long as they are tasteful and don't impair readability.

It was late summer when everything
is full of fire and rounding to fruition.

— Mary Oliver

We're committed to generating
per-ton returns for our members
that exceed market rates over
time and providing a stable outlet
for member processing-grade fruit
by adding value and developing
markets for that fruit.

Tree Top, Inc. is an agri-
cultural cooperative
owned by 2,500 apple
and pear growers
in Washington State,
Oregon, and Idaho.

— Tree Top Mission

This layered initial adds color, dimension and graphic interest to this annual report designed by Hornall Anderson Design Works, Inc.

AMENDMENTS
SINCE
THE BILL OF RIGHTS

This amendment was proposed to the legislatures of the several States by the Third Congress on Mar. 4, 1794. Ratification completed on Feb. 7, 1795.

The Judicial power
of the United States shall not
be construed to extend to any
suit in law or equity, commenced
or prosecuted against one of the
United States by Citizens
of another State, or by Citizens
or Subjects of any Foreign State.

This stately initial is layered in between the text and other colorful typographic elements to bring a restrained excitement to a U.S. amendment in this piece designed by Doyle Partners.

Things to keep in mind when using initials:

- Small caps (see next section) can be very effective when used for the first few words or phrase after an initial letter, and add additional emphasis and visual appeal.

- A lowercase letter can be used as an initial letter as well as a cap (artistic license allowed here!).

- Never repeat the enlarged initial in the text.

SMALL CAPS

Small caps are capital letterforms (or uppercase characters) that are smaller than cap height. When created for a text face, they are usually, and most properly, the height of the lowercase, which usually varies from 60 to 70 percent of cap height. Small caps created for a display face have more flexibility and are often taller than the x-height. True-drawn small caps are superior to computer-generated small caps (which are created by using a Small Caps option in your page-layout program or manually reducing the full caps), as they are drawn to match the weight, color and proportion of the caps, as well as optically match the height of the lowercase. Computer-generated small caps are just reduced caps and therefore look too light and often too narrow. If true-drawn small caps are not available for the typeface you are using and you are intent on using them, occasionally generating them from a heavier weight of the typeface you are using will more closely match the color of the full caps and lowercase.

 True-drawn small caps are available only for certain typefaces from selected font manufacturers and foundries. They are either available with the primary font at no extra cost or sold separately, sometimes as part of an

THE end THE end

THE end THE end

THE end THE end

True-drawn small caps (l.) are superior to computer-generated small caps (r.) in that they are drawn to match the weight, color and proportion of the caps. Computer-generated small caps are just reduced caps and therefore look too light and often too narrow, as you can see in this comparison.

expert set. Each manufacturer has a different keyboard layout for small caps. The most user-friendly layout has the small caps in the lowercase positions, with the caps and all other characters remaining in their normal position. This makes it easy to change a group of words or text to a small-cap font without disturbing any initial caps, punctuation, signs or symbols. Other character layouts (such as Expert Sets) often require additional steps.

Small caps are very useful when the look of all caps is desirable, but with a more refined approach. They are often used in publishing for title pages and page headings, but are also used in headlines, subheads, column head-ings, and very often, as lead-ins for an opening paragraph, usually after an initial cap. Try them instead of all caps for two- or three-letter abbreviations, such as states, times (a.m. and p.m.), companies, etc. They stand out nicely without disturbing the color of lowercase text as much as all-cap settings do, and they take up less space.

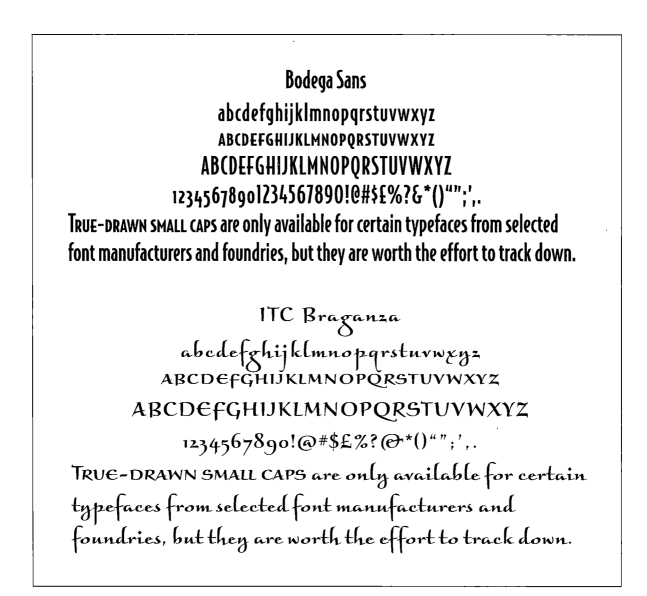

Matrix

abcdefghijklmnopqrstuvwxyz

ABCDEFGHIJKLMNOPQRSTUVWXYZ

ABCDEFGHIJKLMNOPQRSTUVWXYZ

1234567890!@#$£%?&*()""';',.

TRUE-DRAWN SMALL CAPS are only available for certain type-faces from selected font manufacturers and foundries, but they are worth the effort to track down.

Centaur

abcdefghijklmnopqrstuvwxyz

ABCDEFGHIJKLMNOPQRSTUVWXYZ

ABCDEFGHIJKLMNOPQRSTUVWXYZ

12345678901234567890!@#$£%?&*()""';',.

TRUE-DRAWN SMALL CAPS are only available for certain typefaces from selected font manufacturers and foundries, but they are worth the effort to track down.

ITC Highlander

abcdefghijklmnopqrstuvwxyz

ABCDEFGHIJKLMNOPQRSTUVWXYZ

ABCDEFGHIJKLMNOPQRSTUVWXYZ

1234567890!@#$£%?&*()""';',.

TRUE-DRAWN SMALL CAPS are only available for certain typefaces from selected font manufacturers and foundries, but they are worth the effort to track down.

ITC Johnston

abcdefghijklmnopqrstuvwxyz

ABCDEFGHIJKLMNOPQRSTUVWXYZ

ABCDEFGHIJKLMNOPQRSTUVWXYZ

12345678901234567890!@#$£%?&*()""';',.

TRUE-DRAWN SMALL CAPS are only available for certain typefaces from selected font manufacturers and foundries, but they are worth the effort to track down.

These typefaces are available with true-drawn small caps. Some also have both oldstyle and lining figures, making them very useful and versatile additions to your library. All the small caps except those for ITC Braganza are designed to match the font's x-height. Braganza is a very elegant, calligraphic design with tall ascenders and descenders (translate: small x-height), and the small caps are designed to complement the caps rather than match the lowercase.

AMERICAN THE LAWYER

The even color and texture of this logo designed by Gerard Huerta is the result of perfectly balanced caps and small caps as well as precise kerning.

William Hogarth

THEATER

AND THE

THEATER OF LIFE

An exhibition drawn from the collection of
GERALD AND SUZANNE LABINER

16 March to 6 April 1997
Grunwald Center for the Graphic Arts
UCLA at the Armand Hammer Museum of Art and Cultural Center

SPONSORED BY

UCLA Center for 17th- & 18th-Century Studies
William Andrews Clark Memorial Library
Grunwald Center for the Graphic Arts

Mounted in conjunction with a symposium celebrating the
three-hundredth anniversary of the birth of William Hogarth (1697–1764), to be held at the
William Andrews Clark Memorial Library on 4–5 April 1997

[Cover: Detail from *Strolling Actresses Dressing in a Barn*, 1738]

This title page balances a very elegant Spencerian script with more traditional text treatments including cap/small caps settings in this catalog designed by Doyald Young.

OLDSTYLE FIGURES

Oldstyle figures are a style of numeral that approximate lowercase letterforms by having an x-height as well as varying ascenders and descenders. They are considerably different from the "lining" (or "aligning") figures you are probably used to that are all-cap height and usually monospaced so that they line up vertically on charts. Oldstyle figures are more old-fashioned and traditional in nature and are available for only certain typefaces, sometimes as the regular numerals for the font, but more often within a supplementary or expert font. They are proportionately spaced, eliminating the white space that results from monospaced lining figures, particularly around the numeral one.

Oldstyle figures are very useful and often quite beautiful, particularly when set within text, as they blend in smoothly, not disturbing the color of the body copy as much as lining figures do (a problem with all-cap settings as well). Consider using them in headlines, as they don't jump out as much as lining figures. In fact, many people prefer them for just about every use except charts and tables. It's well worth the extra effort to track down and obtain oldstyle fonts; the fonts that contain them might well become some of your favorites.

1234567890
1234567890

Lining (or aligning) figures imitate caps in that they all align on the baseline and the cap height. The oldstyle figures below them approximate lowercase letterforms by having an x-height, as well as varying ascenders and descenders.

The management team from IBM left their office in NY at 11:30 A.M. and arrived at the meeting in NJ at 1 P.M.

The management team from IBM left their office in NY at 11:30 A.M. and arrived at the meeting in NJ at 1 P.M.

Small caps can be substituted for caps when a more subtle look is desired, such as for two- or three-letter abbreviations, states, times (a.m. and p.m.), companies, etc. They stand out nicely without disturbing the color of lowercase text as much as all-cap settings do, and they take up less space. They look particularly good when used with oldstyle figures.

AT seven, he gave a concert in Warsaw. At 17 he made his Paris debut. And in 1906, at 19 he made his first American appearance in Philadelphia.

AT seven, he gave a concert in Warsaw. At 17 he made his Paris debut. And in 1906, at 19 he made his first American appearance in Philadelphia.

Oldstyle figures work well in text as they blend in beautifully by not disturbing the color of the body copy as much as lining figures do. (U&lc)

Reduced to $19.99

Oldstyle figures can also work in headlines; they don't jump out as much as lining figures.

A small amount of information is made visually interesting and eye-catching with the use of oldstyle figures and a simple, yet bold, design in this promotion piece designed by VSA Partners, Inc.

INDENTS

An indent is the space inserted before the first word of a new paragraph. It is a graphic element used to create a visual separation of thoughts in text. It should be neither too small nor too deep but proportional to the size of your type as well as the width of the column. The indent is occasionally omitted in the first paragraph, as there really is no need to separate the beginning of the text from anything, but this is more a matter of style than correctness.

There are several other kinds of indents you can try, as it can be a creative way to add style and visual excitement to an otherwise dull page.

First-line indent

This is when just the first line of a paragraph is indented. It is the most common kind of indent but not the only kind. When making traditional indents, set your tabs manually according to what looks good to you; don't rely on the default tabs of your software to dictate style and taste.

Extreme indent

You will occasionally see the first two or three lines being indented, sometimes to a depth of half the column width. This can be a classy and interesting look when used tastefully and appropriately.

Hanging indent *(outdent)*

This is actually the opposite of an indent in that the first line hangs out to the left of the paragraph into the margin.

Oh! If people knew what a comfort to horses a light hand is, and how it keeps a good mouth and a good temper, they surely would not chuck, and drag, and pull at the rein as they often do.

Our mouths are so tender that where they have not been spoiled or hardened with bad or ignorant treatment, they feel the slightest movement of the driver's hand, and we know in an instant what is required of us.

My mouth has never been spoiled, and I believe that was why the mistress preferred me to Ginger, although her paces were certainly quite as good.

First-line indents are the most common style of indents. Notice that an indent is omitted in the first sentence of the first paragraph as there really is no need to separate the beginning of the text from anything. (Black Beauty)

Oh! If people knew what a comfort to horses a light hand is, and how it keeps a good mouth and a good temper, they surely would not chuck, and drag, and pull at the rein as they often do.

Our mouths are so tender that where they have not been spoiled or hardened with bad or ignorant treatment, they feel the slightest movement of the driver's hand, and we know in an instant what is required of us.

My mouth has never been spoiled, and I believe that was why the mistress preferred me to Ginger, although her paces were certainly quite as good.

An interesting look is achieved with an extreme indent where the first line (or more) is indented, sometimes to a depth of half the column width. This can be a classy and interesting look when used tastefully and appropriately.

Dingbats

A dingbat or any decorative or graphic element (as long as it is simple) can be used to separate paragraphs. This can be done two ways: the paragraphs can run into each other with the dingbat the only separating element, or it can be used in place of a space indent where paragraphs begin on a new line.

Line space instead of indent

The technique of separating paragraphs with an extra line space instead of an indent is often used in correspondence as well as long blocks of text. It adds white space and a more open look when saving space is not a consideration.

Oh! If people knew what a comfort to horses a light hand is, and how it keeps a good mouth and a good temper, they surely would not chuck, and drag, and pull at the rein as they often do.
Our mouths are so tender that where they have not been spoiled or hardened with bad or ignorant treatment, hey feel the slightest movement of the driver's hand, and we know in an instant what is required of us.
My mouth has never been spoiled, and I believe that was why the mistress preferred me to Ginger, although her paces were certainly quite as good.

A hanging indent, or outdent, is actually the opposite of an indent in that the first line hangs out of the left of the paragraph into the margin.

A dingbat or any decorative or graphic element can be used to separate paragraphs. In this example the paragraphs run into each other with only a color dingbat separating the paragraphs. Dingbats can also be used in place of a line space between paragraphs.

Oh! If people knew what a comfort to horses a light hand is, and how it keeps a good mouth and a good temper, they surely would not chuck, and drag, and pull at the rein as they often do. ⚔ Our mouths are so tender that where they have not been spoiled or hardened with bad or ignorant treatment, they feel the slightest movement of the driver's hand, and we know in an instant what is required of us. ⚔ My mouth has never been spoiled, and I believe that was why the mistress preferred me to Ginger, although her paces were certainly quite as good.

LIGATURES

A ligature is a special character made from connecting or combining two characters into one. In the case of oe, ck, st, etc., it is designed to add elegance and refinement to a setting. In other cases, it is created to improve the fit of two characters which crash into each other. The most commonly used ligatures are the f-ligatures, including fi, fl and sometimes ff, ffi and ffl. The first two are accessible on the Mac keyboard (if they are available for the font you are using) by pressing the following keys: option/shift/5 or 6.

A better way to take advantage with most design software is to turn on the use of ligatures in your character preferences. This makes for a consis-

Æ Œ æ œ ꜩ
fi fl ff ffi ffl ſh ſi ſt

A ligature is a special character made by connecting or combining two characters into one. The most commonly used ligatures are the f-ligatures, including fi, fl and sometimes ff, ffi and ffl.

find office affluent after actor
find office affluent after actor
office affluent

The first two lines show the difference in how words look without and with ligatures. If you have ligatures turned on in your application, be careful with ffi or ffl letter combinations where the second and third letters are replaced with the fi or fl ligature as illustrated on the third line; they often look bad when combined with a single "f" preceeding them. If there are no triple f-ligatures available in the font (there usually aren't), use all nonligature characters.

tent job. The other three f-ligatures are nice to have, but are seldom available. One thing to caution you about: if you have ligatures turned on, be careful about ffi or ffl combos where the last two letters are replaced with the fi or fl ligature; they often look bad when combined, and in these instances, I suggest using the nonligature characters.

Some typefaces include specially designed ligature letters purely as design elements. They are a wonderful luxury and, when used carefully, can enhance a headline or text and make for a very elegant and individual look.

Your grandmother had the sweetest temper of any horse I ever knew, and I think you have never seen me kick or bite. I hope you will grow up gentle and good, and never learn bad ways; do your work with a good will, lift your feet up well when you trot, and never bite or kick even in play.

ITC Dyadis, designed by Yvonne Deidrich, contains specially designed ligature letters purely as design elements. They create a very lovely, unique look in text. (Black Beauty)

Alice was not a bit hurt, and she jumped up on to her feet in a moment: she looked up, but it was all dark overhead; before her was another long passage, and the White Rabbit was still in sight, hurrying down it.

There was not a moment to be lost: away went Alice like the wind, and was just in time to hear it say, as it turned a corner, 'Oh my ears and whiskers, how late it's getting!' She was close behind it when she turned the corner, but the Rabbit was no longer to be seen: she found herself in a long, low hall, which was lit up by a row of lamps hanging from the roof.

ITC Highlander Pro, designed by Dave Farey, contains several variations of each weight including one with tall ascenders and descenders as well as others with swash and initial letters. (Alice in Wonderland)

SWASHES AND ALTERNATE CHARACTERS

These are extremely decorative characters that have a flourish or extended stroke at the beginning or the end of the character. They are often available in addition to the regular characters, either as a secondary font or as alternate characters buried within a font. (Access them with Key Caps, Letraset Character Chooser or any other character directory.) They should be used sparingly and thoughtfully. When used this way, they can add an air of elegance or importance to a headline. They are also wonderful when used as initials.

There is one thing to avoid like the plague—using swash characters in all-cap settings. They are almost impossible to read when set one next to the other, and they were not intended to be used this way. Unfortunately, many a type novice will think they are pretty and set an invitation, menu or flyer this way. Just don't do it; it is the surest sign of an amateur.

> *Rain*
>
> *The rain is falling all around,*
> *It falls on field and tree,*
> *It rains on the umbrellas here,*
> *And on the ships at sea.*

These graceful swash characters enhance the appearance of this poem set in ITC Bodoni Seventy-Two. (A Child's Garden of Verse)

Avoid using swash characters in all-cap settings. They are almost impossible to read when set one next to the other, and are not intended for this kind of setting.

BASIC FINE-TUNING AND TWEAKING

ecoming typography savvy is like learning to see in a new way. Details in the typography of ads, magazines, book covers, movie titles and credits, or even bus and subway posters are progressively more apparent to the eye. And details are key. You should never be comfortable with your type until all the details are fine-tuned and tweaked to perfection.

Setting type needs human intervention. A computer can't evaluate and make decisions related to taste, typographic appropriateness and readability. Using the default settings of your design software or your font without fine-tuning the type—looking it over carefully and making changes and adjustments—can lead to a very unprofessional look and be difficult to read.

Prior to the current trend of having "a computer in every home" (or close to it), which has given the ability to set type to virtually everyone, type was set by highly trained typographers who spent years learning the art and craft of good typography. They had very sophisticated, expensive equipment capable of performing complicated tasks on the fly. Desktop computer technology has come a long way in the last decade and is able to perform just about all the tasks that were done by typographers. But a computer can't do it on its own. It requires a human being to tell it what to do and how to do it. The computer is just a tool and still needs a skilled operator to bring out the best of what it can produce. It is like preparing a wonderful recipe; you can just throw ingredients together randomly and live with what you get, or you can measure, taste and adjust until you have just the right balance and the result tastes great and excites your taste buds!

NOTE: To create fine typography on the computer, it is recommended that you use a high-end design application such as QuarkXPress, Adobe Pagemaker or Adobe Illustrator. Word-processing programs are not intended for high-end design and lack the features that allow you to fine-tune type.

TYPE SIZE

Deciding what size to set your type is a very visual thing, but there are some guidelines that can help you make that decision. Let's talk about text settings first. The primary consideration when setting text is usually readability. Assuming you select a font that was designed and intended for smaller settings, the average range for text settings is somewhere between 9 point and 12 point, and sometimes up to 14 point. Anything smaller becomes hard to read in longer settings. Much larger, and it becomes a strain on the eyes for any length of copy.

The size you select is somewhat dependent on the typeface design, as the actual cap sizes and x-heights vary from font to font. The x-height of a font affects its readability and makes different typefaces look larger or smaller at the same point size. Length of the text should also be considered, as well as any constraints on the column width such as a pre-existing grid, for reasons mentioned in the next sections, Line Length and Line Spacing.

Display, or headline, type is primarily meant to catch the eye and draw the reader into the text. For this reason, there are fewer, if any, constraints on size. Whatever works with your layout is probably fine, meaning, try different sizes and see what looks best, and what balances and complements the rest of your layout.

The size you select is somewhat dependent on the typeface design, as the actual cap and x-height vary from font to font. The x-height of a font affects its readability, and will make different typefaces look larger or smaller at the same point size.

The size you select is somewhat dependent on the typeface design, as the actual cap and x-height vary from font to font. The x-height of a font affects its readability, and will make different typefaces look larger or smaller at the same point size.

Both of these examples (ITC Golden Type and Caxton) are set in 12 point but look very different due to their varying x-heights.

A throng of
bearded men,
in sad-
coloured gar-
ments and
grey steeple-
crowned hats,
inter-mixed
with women,
some wear-
ing hoods,
and others
bareheaded,
was assem-
bled in front
of a wooden
edifice.

A throng of bearded men, in sad-coloured garments
and grey steeple-crowned hats, inter-mixed with
women, some wearing hoods, and others bareheaded,
was assembled in front of a wooden edifice, the door of
which was heavily timbered with oak, and studded
with iron spikes.

This line length is comfortable to read and has no hyphenations. (Scarlet Letter)

*A very short line length
can lead to too many
hyphenations, making the
text difficult to read.*

A throng of bearded men, in sad-coloured garments and grey steeple-crowned hats, inter-mixed with women, some wearing hoods, and others bareheaded, was assembled in front of a wooden edifice, the door of which was heavily timbered with oak, and studded with iron spikes.

A long line length for any length of copy also becomes cumbersome to read as our eyes struggle to find the beginning of the next line.

LINE LENGTH

Line length and point size are interrelated, as line length should be some-
what determined by the point size for maximum readability: the larger the
point size, the longer the line length. We read and identify words by the
shapes of the letters, not letter by letter; we also read by groups of words. If
the line length is too short, there will be too many hyphenated words. These
interfere with readability and force the reader to jump to new lines so often
that it affects reading comprehension. On the other hand, line lengths that
are too long can create confusion by making it more difficult for the eye to
find the beginning of the next line in large blocks of text. A general guide is
to have somewhere between 50 to 70 characters per line, but there are many
exceptions to this rule.

LINE SPACING (LEADING)

Line spacing refers to the vertical space between lines of type from baseline to baseline, and is usually measured in points (except for most word processing programs which offer a limited choice of single, one and a half, or double spacing). It is also referred to as leading, which is a term from the days when type was set in metal, and slugs of lead in varying thicknesses were inserted between the lines of metal type to add space between the lines. Too-tight leading makes type harder to read, especially in small sizes. You almost can't add too much leading, but it depends on the amount of copy and your layout. Most design programs have a default setting, called auto leading, which is around 20 percent of the point size. Although you can usually override this in your preferences settings, this is a good place to start. You can then manually make adjustments to suit your taste and work with your layout. Most applications have keyboard shortcuts to do this on the fly.

A very basic guideline for text would be a minimum of 2 points leading (such as 12/14, or 12-point type with 14-point leading) up to 6 points (such as 12/18). Display type can have less leading in general since as type gets larger, the negative spaces associated with line spacing (and letter spacing) appear progressively too large. When setting all caps, throw these rules out the window; all caps can be set with little or no leading (also referred to as set solid) and sometimes negative leading, depending on the look you are after. Without descending characters to worry about, all caps beg to be set tighter than cap/lowercase settings.

But, though the bank was almost always with him, and though the coach (in a confused way, like the presence of pain under an opiate) was always with him, there was another current of impression that never ceased to run, all through the night. He was on his way to dig someone out of a grave.

But, though the bank was almost always with him, and though the coach (in a confused way, like the presence of pain under an opiate) was always with him, there was another current of impression that never ceased to run, all through the night. He was on his way to dig someone out of a grave.

But, though the bank was almost always with him, and though the coach (in a confused way, like the presence of pain under an opiate) was always with him, there was another current of impression that never ceased to run, all through the night. He was on his way to dig someone out of a grave.

The top setting is set solid (12/12) and can be hard on the eyes for any length of copy. The middle text is set at auto leading which is about 20 percent more than the point size, or about 14.5 point; it is comfortable to read, even for lengthy amounts of copy. The bottom text is set at 12/18. It has a nice, open look, and is often used in magazines, annual reports and brochures. (A Tale of Two Cities)

FUNDAMENTAL SINCERITY

IS THE ONLY PROPER BASIS FOR

FORMING RELATIONSHIPS

FUNDAMENTAL SINCERITY

IS THE ONLY PROPER BASIS FOR

FORMING RELATIONSHIPS

The top example is set with auto leading (about 36/43) and is much too open. The example below it is set with negative leading (36/30) and looks much better.

Charles Darwin

Stacked caps can be a very powerful design technique, as in this annual report designed by SVP Partners. The lines have been sized so that the letter spacing isn't compromised.

Line spacing, to a certain degree, has been trend-related in the last few decades. When phototypesetting was first introduced in the 1970s, letter spacing and line spacing had more flexibility than ever before. As a result, designers deliberately set type very tight as a rebellion from the not-so-distant days of hot-metal type when this was not possible. Today, line spacing is leaning toward a more open look, making for better readability and a cleaner appearance with more open space.

ALIGNMENT

The following styles can be used to align type:

Flush left—Flush left is the most common setting for Latin alphabets such as ours (and usually the default setting). It is the style that is most readable and that our eyes are most used to. It aligns the text on the left margin, and leaves the right margin to end wherever it may, dependent on the line width.

Flush right—This style aligns the text on the right with a ragged left margin, but it is more difficult to read since our eyes have to follow a wavering left-hand margin when they move to the next line down the column. It should be used only when a specific design objective is desired.

Justified, or *flush left and right*—In this style, space is inserted between words and sometimes letters to *stretch* a line so that both margins align. This creates a very geometric block of copy that is sometimes desirable. Although very commonly used (most newspapers use it), this is a tricky technique to apply tastefully if you do not take the time to fine-tune it. When lines of type are stretched in this way, the color, texture and readability of the type can be degraded tremendously by the white space that is inserted to align both edges. In some cases (dependent on your software and the settings in your preferences), the actual characters are compressed or expanded electronically to achieve this alignment. This is the ultimate no-no! Justified settings can also create rivers of white space, which should be avoided at any cost. All of this manipulation can lead to some very poor typography.

In order to avoid some of the problems inherent in justified settings, try making your line length a bit longer than usual, or make your type smaller.

There were six young colts in the meadow besides me; they were older than I was; some were nearly as large as grown-up horses. I used to run with them, and had great fun; we used to gallop all together round and round the field as hard as we could go.

A traditional flush-left setting. (Black Beauty)

There were six young colts in the
meadow besides me; they were
older than I was; some were nearly
as large as grown-up horses. I used
to run with them, and had great
fun; we used to gallop all together
round and round the field as hard
as we could go.

Flush right; a little harder to read, but acceptable in short amounts where it is desired for design purposes.

There were six young colts in the meadow besides me; they were older than I was; some were nearly as large as grown-up horses. I used to run with them, and had great fun; we used to gallop all together round and round the field as hard as we could go.

When justifying type, avoid rivers of white space and lines with too much letter spacing or word spacing. Try to maintain an even color and texture as much as possible, even if it means editing the copy or altering the line length.

There were six young colts
in the meadow besides me;
they were older than I was;
some were nearly as large as
grown-up horses. I used to
run with them, and had
great fun: we used to gallop
all together round and
round the field as hard as we
could go.

Centered type adds symmetry and elegance but decreases readability when used for large amounts of copy.

The more words you can fit on a line, the less space you will have to add to justify it. Once you've settled on an optimum size and width, it might be necessary to edit your copy to fix lines that are too open or too tight, or that have too many hyphenated endings, particularly if there are more than two of these lines in a row. This can be a lot of work, especially if you have to go back to your copywriter to do it, but it will make for a much more professional-looking job.

It is also a good idea to become familiar with your software's settings for hyphenation and justification (H&J). You can actually tell it how much it is allowed to stretch or squeeze a line of type, as well as your hyphenation preferences. Mastering this might seem a bit overwhelming at first, but it is well worth the time it takes to become familiar with these settings and how they affect the look of the type.

Centered type–This style can be very effective when used for short blocks of copy, such as headlines, subheads, invitations, announcements and poetry. It centers the lines of type without adding extra space, making a ragged right and left edge. This technique adds symmetry and elegance but decreases readability when used for large amounts of copy.

Wrap-around type (*run around* or *text wrap*)–This is type that aligns around the contour of an illustration, photo or other graphic element. It can be applied to either the right, left or both margins.

Contoured type–Contoured type is set in a particular shape for purely aesthetic reasons. It is usually justified to achieve a particular shape. If there are narrow line widths, it will probably require editing the copy and hand-working the rags to avoid too-open letter and word spacing as well as rivers of white space and stretched or squeezed lines.

It did so indeed, and much sooner than she had expected: before she had drunk half the bottle, she found her head pressing against the ceiling, and had to stoop to save her neck from being broken. She hastily put down the bottle, saying to herself 'That's quite enough–I hope I shan't grow any more– As it is, I can't get out at the door–I do wish I hadn't drunk quite so much!'

Type can run around a pull-quote inserted in a reverse box. Align the box with the baseline and cap height of neighboring lines. (Alice in Wonderland)

You promised to tell me your history, you know,'
said Alice, 'and why it is you hate−C and D', she
added in a whisper, half afraid that it would be
offended again.

Mine is a long and a sad tale!' said the Mouse, turn-
ing to Alice, and sighing.

It IS a long tail, certainly,' said Alice, looking down
with wonder at the Mouse's tail; 'but why do you
call it sad?' And she kept on puzzling about it while
the Mouse was speaking, so that her idea of the tale
was something like this:−

'Fury said to a
mouse, That he
met in the
house,
"Let us
both go to
law: I will
prosecute
YOU. −Come,
I'll take no
denial; We
must have a
trial: For
really this
morning I've
nothing
to do."
Said the
mouse to the
cur, "Such
a trial,
dear Sir,
With
no jury
or judge,
would be
wasting
our
breath."
"I'll be
judge, I'll
be jury,"
Said
cunning
old Fury:
"I'll
try the
whole
cause,
and
condemn
you
to
death."'

In this excerpt from Alice In Wonderland, *type is contoured as a wonderful play on the words, "'Mine is a long and a sad tale!' said the Mouse..."*

Abigail Anstey and Catherine Healy are the 'doyennes des vins', creating individualistic & narrative branding, including identities for a dozen Oregon vineyards. BY MARGARET RICHARDSON

ANSTEY HEALY DESIGN CREATES PACKAGING THAT CAPTURES AN AMBIANCE AND A LIFE-STYLE AS WELL AS A PRODUCT

Abigail Anstey & Catherine Healy, the two principals of the Portland, Oregon, design studio, maintain that they have no one style for the branding development they do; rather, they focus on delving into the unique qualities of each company, finding the personality and "story" for each and interpreting these elements into a style that suits each client.

If Anstey Healy's clients have common traits, these are a high-quality product and an entrepreneurial spirit. The studio's shelves are filled with stylish packaging for a variety of gourmet goodies from potato chips, exotic sauces, and brown-sugar shortbread to a range of herb supplements. But the most prolific designs are for wine, spirits, & beer.

Anstey Healy boasts a dozen wineries among its clients. Each of the wine bottles has a strong identity, capturing the tone of the vintner as well as the quality of the wine. Although all the designs are characterized by finely wrought type treatments and obsessive attention to detail, they have individual personalities. Abigail Anstey explains how the studio manages this feat: "We work very closely with the winemakers and the owners. So much of what we do, the success of what we do, comes out of our 'reading' of the client's story, including what they are trying to say and what this wine is about. Going into depth with the owners, makers, growers—that is what gives us the wealth of information that we need to create the dramatically different stories for the labels."

VIN DE
TABULA RASA
[RED TABLE WINE]

21

respond to the client's instinctive response. "If the client just can't stand yellow," says Healy, "for whatever reason, we listen, and we won't use yellow." Both suggest that their clients' emotional, creative, and personal involvement with the designs is the key to the ongoing designer/client relationships that the studio maintains.

Two clients the designers cite as particularly outstanding to work with are King Estate and Widmer Brothers Brewing Company.

King Estate, with vineyards south of Eugene, Oregon, produces pinot noir and chardonnay wines. The winery emulates the quality, the grapes, and the look expected from the wine growers of Burgundy. This isn't just a ploy. Wine author Tom Maresca in *The Right Wine* echoes other wine critics in saying: "The Pinot Noirs of—surprisingly Oregon—provide the closest approximation most of us can afford to the taste of classic Burgundy..." King Estate hired Anstey Healy to take their existing, overly formal labeling program and bring a stronger personality to their image. Healy describes a current project for King Estate (one that will take a year to finalize) where the client wanted an elegant, stylish label for a limited-edition wine. She presented three design approaches for this "haute couture" wine, each of which presented a different attitude to the "top-tier tone." One design offered a "back-room" look—the label was designed to appear as if the wine was not for sale, but covetable. The second version was like a "little black dress," austere and elegant. The third was an information- or document-based approach, with appropriate blanks to fill in. There was much discussion of the three approaches, and as the result of a six-hour meeting all the designs were accepted. King Estate will now create three special wines, one for each version.

For Widmer Brothers Brewing Company, the challenge for Anstey Healy was to make Widmer stand out in a highly competitive sales environment. (The *Oregonian* newspaper describes Portland as "the first and biggest hotbed of microbrewing, a term the original brewers such as Widmer, Full Sail, BridgePort, and Portland now eschew in favor of 'craft brewing.'") Anstey Healy Design was hired to "put more personality and more character" into the seasonal packaging, starting with Widmer's "Sömmerbräu." The bright, cheerful, sunny label was cited as the impetus for a "spectacular increase in sales," according to Anstey. "We tried to make the label more emotional, and more connected to the consumer," she adds.

Anstey and Healy talk about the sheer excitement of collaborating with these clients, where much of what they do is based on mutual respect and trust. Their own working relationship has followed a similar path over ten years. The two met when Anstey taught at the Pacific Northwest College of Art and Healy was her student. As Anstey relates, "Catherine was just the best student I had ever seen." Anstey worked with Healy as teacher with student, and as thesis advisor, and she arranged for Healy to intern in her studio. Healy then freelanced there for two years, and in 1993 the two formed their partnership. There was never any

doubt for Anstey that she and Healy would inevitably work together. As she puts it, "As soon as I saw Catherine's talent, I knew I'd found my working partner." Healy welcomed the challenge, recalling, "As we worked together as student and teacher, Abigail pushed the things I wanted to push in myself." Healy recalls taking a tour of the studio in her sophomore year and knowing right then that that was where she wanted to work.

Their work, which has received the highest awards from the wine industry as well as from design organizations, evolved from Anstey's first encounter as a junior designer at a corporate agency, where she was set to work on the packaging accounts (which the agency considered "fluff"). When that agency closed, Anstey took the packaging accounts with her, and opened her own agency. Her first foray into packaging for alcoholic beverages was for the prestigious Clear Creek Distillery (makers of McCarthy's Oregon Single Malt, Blue Plum Brandy, Kirschwasser, and Eau de Vie de Poire). Next came the BridgePort Brewery, for which the designers created an embossed bottle as well as the neo-traditional label. BridgePort was then owned by the Ponzi family, well-established vintners known also for their pinot noir. Anstey Healy was asked to create the packaging for another tier of Ponzi wines: Vino Gelato (an ice riesling), Arneis, and a sparkling wine. These were expensive gift items, dessert wines in elegant half-bottles (or, in the case of the sparkling wine, in full-size champagne-style bottles). The designs capture the allure of each individual wine, through meticulous type and subtle script, with soft colors and an illustration for the Arneis rendered by Anstey.

Other vintners soon found their way to the design firm. According to Anstey, "The wine industry, especially in Oregon, is such an unusually mutually supportive community that there isn't the competitive nature that you find in other products, like beer. They sell each other grapes. So the Ponzis recommended us to other wine makers. And we started getting a lot of press—and here we are speaking as experts at national conferences on wine packaging."

The clients keep coming. The firm has been approached by California vintners (they would also like to design for vineyards abroad), and they are just finishing the packaging for the launch of a "mead" from Sky River Meadery. When asked what their list of "fantasy" projects would include, they mentioned designing lines of cosmetics, natural food, and specialty housewares (preferably with tiers and sub-brands). These they aspire to because, according to Catherine Healy, "We do best with companies which are trying to communicate very high-quality craftsmanship."

And as Abigail Anstey puts it, "Working with an entrepreneur or a company that is extremely vibrant and still in touch with its vision—where we can maintain a personality in the design—that's when we're at our best."

MARGARET RICHARDSON is a writer based in Portland, Oregon.

25

These spreads from U&lc show how Mark van Bronkhorst contoured the type to mirror shapes from the facing page. It might look easy to do, but the copy and the line breaks were edited and hand-worked to eliminate holes and rivers, keeping the texture and color of the type even.

We are bats for a night! We awake at dusk to forage for food, emitting incredibly high-pitched squeaks and clicks through our mouths at 50,000 cycles per second (the neighbors think we're yawning; they can only hear up to 20,000 cycles). The sound waves we make bounce off everything in our path – family members, buildings, light aircraft – and return to our ears as echoes. Our brains quickly shape the echoes into detailed pictures in sound. Ha! We "see" our prey – a drive-through fast food menu! We zoom toward it at 30 miles an hour! But the people inside scream in a slow, deep rumble. Shouting reassurance, we notice the sound patterns of moths under the streetlights. How tasty they look! Quick – hors d'oeuvres! We'll sing for our supper until just before dawn, then we'll go home and put our feet gratefully on the pillow.

The text in this smart piece by Hornall Anderson Design Works, Inc. was contoured into a triangle to complement the concentric circles in the background. Once again, it looks easy, but is difficult to do well.

An interesting text shape coupled with the geometric text architecture above it make an exciting page out of text set in conservative typefaces in this catalog designed by Eva Roberts. Notice the use of bullets to separate the paragraphs.

VOLUME II NUMBER 2

A FEW WORDS ABOUT RAGS

When setting type with a ragged margin (flush left or flush right), learn to become aware of the shape that the ragged line endings are making. A good rag goes in and out in small increments. A poor rag is one that makes unnatural shapes with the white space. When this occurs, make manual line breaks or edit your copy to improve the rag.

WIDOWS AND ORPHANS

A widow is very short line, usually one or two words, at the end of a paragraph. This is typographically undesirable, as it is disturbing to the eye and creates the appearance of too much white space between paragraphs or at the bottom of a page. It is considered very poor typography, so adjust it by rebreaking the rag or editing the copy.

An orphan is related to a widow in that it is a single word or very short line appearing at the beginning of a column or a page. This terminology is not as commonly used and understood as widow, but the concept is the same, and so is the solution: fix it!

AVEDA At Aveda, beauty begins from the ground up. Creator of hair care and beauty products and services, Aveda integrates environmental responsive practices into every aspect of its business. Reduce, re-use and recycle initiatives are key to its manufacturing processes. And its Environmental Lifestyle Stores and Aveda Concept, Salons and Spas promote services and products created from organically grown plants and other "renewable sources of wellness." Packaging too is designed to reduce pre- and post-consumer waste, and collateral materials are printed on recycled paper with natural soy-based inks.

Organica, its corporate restaurant, serves only fresh-ingredient foods grown without hazardous pesticides or synthetic fertilizers. Kitchen refuse is composted, wax-coated produce boxes are reused and plates, utensils and drinking glasses are the washable kind.

Aveda has made an example of its Minneapolis corporate headquarters as well. Surrounded by 65 acres of wetland and organic landscaping and adjacent to a 1,000-acre protected wetland, Aveda's facilities utilize landscape windows and skylights to make the most of direct sunlight.

As a result of these efforts, corporate office and manufacturing waste has been reduced by 33 percent, solid waste per employee by 29 percent and solid waste per gallon of product by 66 percent, the company says. "Aveda is a lifestyle product and service company committed to supporting two ecosystems: the planet and the human body," claims founder and chairman Horst Rechelbacher. "Each thrives on harmony and balance and is vitally interconnected." Explaining why Aveda became the first company to sign the stringent CERES Principles (Corporations for Environmentally Responsible Economics) in 1989, Rechelbacher has stated, "We must conduct all aspects of business as responsible stewards of the environment by operating in a manner that protects the earth. We believe that corporations must not compromise the ability of the future generations to sustain themselves."

A very whimsical and charming use of contoured type to create a head of hair with copy that talks about a hair care company. (Designed by VSA Partners, Inc.)

Not many days after we
heard the church-bell
tolling for a long time,
and looking over the
gate we saw a long,
strange black coach
that was covered with
black cloth and was
drawn by black horses;
after that came another
and another and
another, and all were
black, while the bell
kept tolling, tolling.
They were carrying
young Gordon to the
churchyard to bury
him. He would never
ride again. What they
did with Rob Roy I
never knew; but 'twas
all for one little hare.

Not many days after we
heard the church-bell
tolling for a long time,
and looking over the
gate we saw a long,
strange black coach that
was covered with black
cloth and was drawn
by black horses; after
that came another and
another and another,
and all were black, while
the bell kept tolling,
tolling. They were carry-
ing young Gordon to
the churchyard to bury
him. He would never
ride again. What they
did with Rob Roy I never
knew; but 'twas all for
one little hare.

When setting type flush left, be aware of the shape that the ragged line endings are making. A good rag goes in and out in small increments. A poor rag such as this one makes unnatural shapes with the white space. (Black Beauty)

The rag in the example at the left can be easily corrected by making manual line breaks.

The next unpleasant busi-
ness was putting on the
iron shoes; that too was
very hard at first. My
master went with me to
the smith's forge, to see
that I was not hurt or got
any fright. The black-
smith took my feet in his
hand, one after the other,
and cut away some of the
hoof.

The next unpleasant busi-
ness was putting on the
iron shoes; that too was
very hard at first. My
master went with me to the
smith's forge, to see that I
was not hurt or got any
fright. The blacksmith took
my feet in his hand, one
after the other, and cut
away some of the hoof.

On the left is an example of a horrible widow, which can be corrected by making a minor adjustment in the line length (r.). (Black Beauty)

Hyphenated words are a necessary evil in typesetting. They are pro for a better looking, tighter rag, or a more natural block of justified type which needs less stretching.

ADVANCED FINE-TUNING AND TWEAKING

O nce the actual type is adjusted, making it the best size, alignment and format possible, it's time to make it visually appealing. A page of text should look smooth and not be disrupted by typographic errors which, seemingly insignificant, can make a huge difference in the appearance of your text.

HYPHENATION

Hyphenated words are a necessary evil in typesetting. They allow for a better looking, tighter rag, or a more natural block of justified type which needs less stretching. They also allow you to fit more words in a line.

It is acceptable to have two lines in a row ending in a hyphenated word, but no more. Be careful not to have too many hyphenated line endings in a paragraph even if they are not in successive rows, as it affects the readability. Most page-layout programs allow you to customize the hyphenation and justification (H&J) preferences to your liking. Familiarize yourself with this function, as it is essential to getting your type to look the way you want.

If tweaking this automatic function doesn't get the results you want, try manually rebreaking the troublesome lines, or if possible, edit your copy (or have your editor do this) to achieve a better flow. Additionally, sometimes adjusting the width of the column ever so slightly will result in fewer breaks.

HUNG PUNCTUATION

In a block of copy aligned flush left (or justified), when certain punctuation marks, such as an apostrophe or quotation mark, occur at the beginning of a line, it visually appears as if that line is indented slightly, disturbing the desired alignment. The same is true when these punctuation marks as well as others, such as a period or comma, appear at the end of a line in a block of copy aligned flush right (or justified). This is because these characters are smaller than most others and have a lot of white space above or below them. In order to help your margins visually align, it helps to extend the punctua-

tion beyond the margin just a bit to optically make the copy look aligned. This is called "hanging punctuation" or "hung punc." This is a highly professional, sophisticated technique that is worth the effort to achieve. It might look wrong at first if you are not used to it, but when you move away from the type and look at it as a whole, you will see an improvement.

This can be difficult to achieve with most design programs, especially in long blocks of text, as most applications do not yet have the capability to do this on the fly, or via preferences. It might require creating a separate text box for the hanging punctuation. When you do this, make sure to delete the

Here is a man suffering from inner restlessness and cannot abide in his place. He would like to push forward under these circumstances, but repeatedly encounters insuperable obstacles. Therefore his situation entails an inner conflict. This is due to the obstinacy with which he seeks to enforce his will. If he would desist from this obstinacy, everything would go well.

Here is a man suffering from inner restlessness and cannot abide in his place. He would like to push forward under these circumstances, but repeatedly encounters insuperable obstacles. Therefore his situation entails an inner conflict. This is due to the obstinacy with which he seeks to enforce his will. If he would desist from this obstinacy, everything would go well.

Here is a paragraph with no less than seven horrendous hyphenations in a row! It can easily be improved with some manual breaks, as seen on the right. (The I Ching)

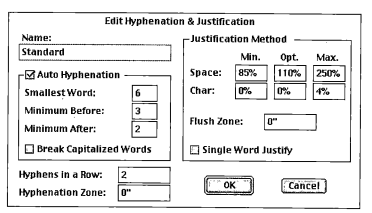

Familiarize yourself with the hyphenation and justification (H&J) function of your page-layout program, as it is essential to making your type look the way you want. The left side of this QuarkXPress dialog box allows you to customize your hyphenation preferences.

'Curiouser and curiouser!' cried Alice (she was so much surprised, that for the moment she quite forgot how to speak good English); 'now I'm opening out like the largest telescope that ever was! Good-bye, feet!' (for when she looked down at her feet, they seemed to be almost out of sight, they were getting so far off). 'Oh, my poor little feet, I wonder who will put on your shoes and stockings for you now, dears?'

'Curiouser and curiouser!' cried Alice (she was so much surprised, that for the moment she quite forgot how to speak good English); 'now I'm opening out like the largest telescope that ever was! Good-bye, feet!' (for when she looked down at her feet, they seemed to be almost out of sight, they were getting so far off). 'Oh, my poor little feet, I wonder who will put on your shoes and stockings for you now, dears?'

Hanging punctuation is a technique that gives your typography a very professional look. By extending the punctuation beyond the margin until the neighboring character aligns with those above and below it, the visual alignment of your margins will improve. Check out both the left and right margins of these "before and after" examples to see the improvement.

'Curiouser and curiouser!' cried Alice (she was so much surprised, that for the moment she quite forgot how to speak good English); 'now I'm opening out like the largest telescope that ever was! Good-bye, feet!' (for when she looked down at her feet, they seemed to be almost out of sight, they were getting so far off). 'Oh, my poor little feet, I wonder who will put on your shoes and stockings for you now, dears?'

Hung punctuation can be difficult to achieve with most design programs, especially in long blocks of text, as most applications do not have the capability to do this on the fly, or via preferences. It might require creating a separate text box for the hanging punctuation, as in this example using QuarkXPress. (Alice in Wonderland)

"offending" punctuation from the original text block so it is not repeated. If using this method, be careful when you make any other changes that might disturb the location of the hung punctuation. It is probable that future upgrades of existing programs will incorporate this function, but until then, it is worth the time to do it manually if you want truly professional typography.

VISUAL ALIGNMENT

The concept of visual alignment takes hung punctuation one step further. Your computer aligns characters (including punctuation, figures and symbols) by the edge of the character plus its sidebearing. The characteristics of the spacing of certain characters, such as a cap T or A or the numeral 1, as well as periods, commas, apostrophes, dashes and quotations marks, create a visual hole or indentation when seen above or below other characters.

This problem is most noticeable in larger type settings such as headlines, subheads and initial letters. When this occurs, the line should be moved in or out until it visually or optically aligns. There are two ways to do this. One method is to create a separate text box for the offending line so that it can be adjusted independently from the others. The other method, which is a reverse

"I wish I hadn't mentioned Dinah!" she said to herself in a melancholy tone. "Nobody seems to like her, down here, and I'm sure she's the best cat in the world! Oh, my dear Dinah! I wonder if I shall ever see you any more!" And here poor Alice began to cry again, for she felt very lonely and low-spirited.

"I wish I hadn't mentioned Dinah!" she said to herself in a melancholy tone. "Nobody seems to like her, down here, and I'm sure she's the best cat in the world! Oh, my dear Dinah! I wonder if I shall ever see you any more!" And here poor Alice began to cry again, for she felt very lonely and low-spirited.

Aligning initials with punctuation can be tricky. The example on the left is aligned by the quotes, but even though they are set smaller than the initial for better balance, it still creates an unwanted visual indentation. The appearance improves when the initial is aligned by the square serifs, letting the quotes hang into the left margin. There are no rules here—just move things around until it looks right. (Alice in Wonderland)

approach, is to add small, invisible (set color to white or "none" in your page-layout program) characters, such as periods or the numeral one repeated before the longer lines to indent them slightly.

It is helpful to look at your text from a slight distance when correcting problems since it is difficult to know how much of an adjustment is enough. When in doubt, less is more until you get the hang of it. Don't try to adjust small-sized type or large blocks of text, as it is much too time-consuming, and the results are barely visible at text sizes.

Visual alignment not only relates to the horizontal positioning of lines of type, but vertical positioning as well. In cases where lines with lots of ascenders and/or descenders are preceded or followed by lines with few or no ascenders and descenders, the lines will appear to have varying leading while they are all actually the same. You will need to adjust the leading between each line to give the appearance of their being equidistant from each other.

NOTE: When using an italic type, you might notice that it almost never seems to align vertically. In most cases, this is an optical illusion. Beware of making too many adjustments here (if any at all!), or you will wind up with all of your copy askew!

Vertical alignment is often overlooked because many people assume that consistent leading results in visual balance—not always so! The example at the top is set 24/28, but due to the lack of descenders in the third line and the few ascenders in the fourth line, these lines appear to be further apart than the rest. When the leading is adjusted for each individual line (the bottom example), the appearance improves, even though the last line is now set with negative leading, 24/23!

YOU'VE probably heard of "Thighs of Steel," "Buns of Steel," and other popular physical fitness titles. But you've probably never heard of an exercise program called "Superior Rectus of Steel"– nor should you. That muscle, along with the inferior rectus and the lateral rectus muscles, controls the movement of the human eyeball. Although I've seen and read many texts that would qualify for the title, our goal, as typesetters, is to avoid giving the reader's eye a workout.

BAD LINE BREAKS & HYPHENATION POINTS make a reader's eye work harder. What happens? You have to skip *back* in the text— back to the end of the previous line, then ahead to the next line, to try to parse the poorly hyphenated word. When you read a hyphenated word, you do two things: you store the first part of the word in your short-term memory, and you make guesses about what the second part of the word will be. All of this happens very fast, and, for most readers, happens below the conscious level. Poor hyphenation raises this process to the conscious level—and suddenly you're thinking about the mechanism of reading, rather than the content of the text. Your eyes get tired, and you get grumpy.

Damned if you do

Given the risk of producing "read rage," why do we use hyphenation at all? Because, without hyphenation, we face horrible letter- and word-spacing in justified text, or wide variation in line lengths in non-justified copy—both of which are at least as irritating to the reader as bad hyphenation.

Like just about everything else having to do with type, it's a balancing act. You've got to work with the word- and letterspacing of your text (as I've mentioned in previous issues), and you've got to watch every line break. And, yes, this means you have to read and at least partially understand the text. There's just no other way.

The hyphenation controls in your page layout program can help you—provided you understand that they're not (and probably can't be) perfect. You've got to help them out—left to their own devices, today's page layout programs are almost guaranteed to produce hyphenation problems. Namely:

☞ *Bad breaks.* Hyphenation breaks should always fall between syllables, and should never appear inside a syllable—but every desktop publishing program will break inside a syllable in certain conditions.

☞ *Short fragments.* When the part of a word before or after the hyphen is too short, readability suffers. You've probably seen paragraphs ending with a line containing only "ly" or "ed."

☞ *"Ladders" of hyphens.* When you see successive lines ending with a hyphen, you're looking at a "ladder" of hyphens. Ladders of hyphens can cause the reader's eye to skip ahead several lines in the text. This is less of a problem (from the reader's point of view) than badly spaced lines. There are two ways to approach this problem.

16

The type which hugs this oversized initial in U&lc has been positioned very carefully to visually align.

In this poem set in italics, the lines appear to be too far to the right. This is an illusion! But adjusting them, even just a little, will often result in the whole text block being askew.
(A Child's Garden of Verse)

At the Seaside

When I was down beside the sea
A wooden spade they gave to me
To dig the sandy shore.

My holes were empty like a cup.
In every hole the sea came up,
Till it could come no more.

KERNING

Kerning is the adjustment of the space between two specific characters. It most commonly refers to a reduction of space, but can refer to adding space as well. This is done to balance the white space between certain letter combinations in order to create an even color and texture, as well as to optimize readability.

A quality typeface or font is designed so that each character is spaced to allow for optimum overall letter spacing with as many characters as possible. The spacing consists of the width of the character plus the right and left side bearings. But due to the quirks of our Latin alphabet, there are many combinations that don't naturally fit together well and need adjustments. Another factor to be considered is that fonts are kerned (and spaced) to look their best at a particular size range. For this reason, you will find that at larger point sizes, spatial relationships change, and a well-kerned font might still need some tweaking at certain sizes, particularly in headlines.

The object of proper letterfit (and the goal of kerning) is to achieve even texture and color balance between characters, which leads to a consistent overall texture. This sounds great theoretically but can be difficult to achieve due to the idiosyncrasies of the individual designs of the characters of the alphabet. One way to look at it is to imagine pouring sand in between each pair of characters; each combination should have roughly the same amount of sand. With time and experience, your eye will become more trained, and fine-tuning type will become second nature to you.

Most fonts (but not all) come with kern pairs built in, and they usually number between two hundred and five hundred pairs. There are certain commonly known pairs that almost always need to be kerned, such as Ta, Ye and AV, etc. Many manufacturers concentrate on only these combinations, and therefore you might find many others that need adjustment, such as characters next to punctuation, symbols or numerals. A high-quality font can have over a thousand kern pairs, but this alone doesn't mean it will look good. If a typeface isn't spaced well to begin with, it will need many more kern pairs than a properly spaced font. Kerning ought not to be used as a Band-Aid for a poorly spaced font.

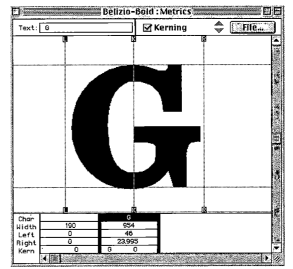

A character's spacing consists of the width of the character plus the right and left sidebearings. This character has 46 units of space on the left and 24 on the right, as indicated below it.

In any case, there are several things you can do to improve the appearance of your type. First of all, make sure that kerning is turned on in the type preferences of your page-layout program. Some programs have defaults that turn on kerning at 12 point; this should be adjusted to as small a size as possible.

Fa Pa Ta Ye We rk AV PA AT

F. T. Y. P, ." y. r, f' 7. -7 's

Fa Pa Ta Ye We rk AV PA AT

F. T. Y. P, ." y. r, f' 7. -7 's

Wail Vincent Van Gogh New York

February 7, 1957. (516) 784-1716

Wail Vincent Van Gogh New York

February 7, 1957. (516) 784-1716

There are certain commonly known pairs that almost always need to be kerned, such as Ta, Ye and AV, as well as characters next to punctuation, symbols or numerals. Here you can see how some of these combinations look before and after kern adjustments.

Typographic Preferences

Superscript
Offset: 33%
VScale: 100%
HScale: 100%

Subscript
Offset: 33%
VScale: 100%
HScale: 100%

Baseline Grid
Start: 0.5"
Increment: 12 pt

Small Caps
VScale: 75%
HScale: 75%

Superior
VScale: 50%
HScale: 50%

Leading
Auto Leading: 20%
Mode: Typesetting
☑ Maintain Leading

☐ Accents for All Caps
☑ Auto Kern Above: 4 pt
Flex Space Width: 50%
Hyphenation Method: Enhanced
☐ Standard em space

☑ **Ligatures**
Break Above: 1
☑ Not "ffi" or "ffl"

[OK] [Cancel]

Some programs have defaults that turn on kerning at 12 point; this should be adjusted to as small a size as possible. Shown here is the Typographic Preferences dialog box in QuarkXPress, which allows you to customize the Auto Kern feature on the lower left.

"*Work with the best people. Be sure they're fully engaged in the process. Encourage them to disagree with you, and respect their contribution.*"

Beautiful use of properly kerned italics in this colorful piece designed by VSA Partners, Inc. Notice the closed quotes, which are kerned to sit above the period and also hang slightly into the right margin to appear optically aligned.

NOTE: Be aware that if you are using certain word-processing programs (as opposed to a page-layout or design program), they might not read the kern pairs at all.

Most design programs have the capability to adjust kerning and tracking manually, or case by case in each document. There are often keyboard short-cuts for these functions that are very helpful when you are making many adjustments. When doing this, make sure to proof what you have done on a high-resolution printer. Kerning on the screen is extremely deceptive, as your screen is only 72 dots per inch, while the actual printed piece is a much higher resolution. It will become easier to judge how much to kern when you get the hang of it and know what five units actually look like for your application, as unit values vary from application to application.

It is important to keep a few more things in mind when kerning your work. Any kern changes you make apply only to the pair that you have high-lighted and not the actual font. This means that if you want your document to be consistent (and by all means it should be), you have to search for all same combinations and kern them the same value. This is most important in headlines where variances are most obvious and are extremely undesir-able and unprofessional.

If you really want to get serious about kerning and want to make perma-nent kern adjustments in the actual font, there are a number of kerning utili-ties or extensions that can help you do that. They will actually make a new suitcase for your font with the changes so you can eliminate any kerning in your actual document. This is a very good idea if you have a few favorite type-faces and don't want to be bothered kerning every time you use them.

NOTE: Be sure to send your revised font suitcase to your service bureau or printer if they are outputting your piece from other than a PostScript file, or they might use another version and none of your painstakingly done kern work will show up.

You can also use Fontographer, which is one of the most commonly used typeface design and manipulation programs. Kerning capability is only one of its many features, but it does an excellent job of it and can make fonts in any format or platform.

Numerals, or figures, as they are often referred to, have their own special spacing and kerning problems. In many fonts, particularly text fonts, num-erals have tabular spacing, also called monospacing. That is to say, they all have the same total width, even the numeral one, which is a very narrow character. This is why the "1" in years and dates often appears separated from surrounding numerals. Tabular spacing is done to allow the numerals to align vertically in charts and tables. But if you are not doing tables, and espe-cially if you are using numerals in headlines, the figures should be kerned, *especially the numeral one!*

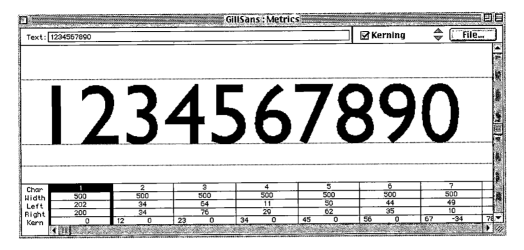

Char	1	2	3	4	5	6	7	
Width	500	500	500	500	500	500	500	
Left	202	34	64	11	50	44	49	
Right	200	34	76	29	62	35	10	
Kern	0	12 0	23 0	34 0	45 0	56 0	67 -34	78

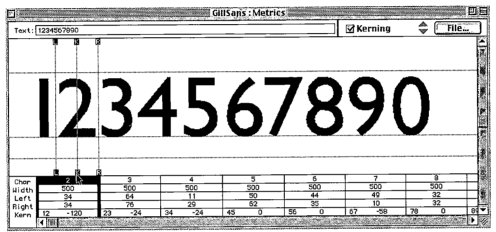

Char	2	3	4	5	6	7	8	
Width	500	500	500	500	500	500	500	
Left	34	64	11	50	44	49	32	
Right	34	76	29	62	35	10	32	
Kern	12 -120	23 -24	34 -24	45 0	56 0	67 -58	78 0	89

The top example shows the tabular-spaced numerals of Gill Sans. Notice how they all have the same width (500 units) to allow them to align vertically in tables. If you don't need them for that purpose and want to improve the letterfit, you can adjust the kerning in Fontographer as shown at the bottom.

1234567890

1234567890

January 23rd, 1917

January 23rd, 1917

You can see the improvement in the spacing of the numerals after they have been kerned, especially the year.

TRACKING (OR LETTER SPACING)

Tracking is the addition or reduction of the overall letter spacing in a selected block of text. In most page-layout programs, it can be applied in small increments. This is a very helpful function for fine-tuning the color of your type.

As stated previously, fonts are spaced and kerned to look their best at certain point-size ranges. If your type is much smaller than this range, you will want to open the tracking to improve the readability, as the letters will probably get too close and even begin to touch. Conversely, when you set type at larger sizes, you might need to tighten up the tracking to keep the words from falling apart, so to speak. Some fonts might not be spaced to your liking at *any* size and will need adjusting just to give them the balance you are looking for. For example, many older fonts are spaced extremely tight and often need adjustment.

The term "letter spacing" can also refer to the popular style of setting very open type for stylistic and design purposes. This technique is most effectively used with all-cap settings that don't depend on their letter shapes to be recognized. But unfortunately it is commonly misused and abused. When it *is* used, it should be limited to a few words or small amounts of copy, as it definitely reduces readability.

You can adjust tracking easily in QuarkXPress—just highlight the text that you want to change and insert the value in the dialog box. It can also be adjusted in the measurement style bar or by using keyboard shortcuts.

Tracking is the addition or reduction of the overall letterspacing in a selected block of text. In most page layout programs, it can be applied in small increments. This is a very helpful function for fine-tuning the color of your type.

Tracking is the addition or reduction of the overall letterspacing in a selected block of text. In most page layout programs, it can be applied in small increments. This is a very helpful function for fine-tuning the color of your type.

Fonts are spaced and kerned to look their best at certain point-size ranges. If your type is much smaller than this range, especially if it's a very bold typeface such as ITC Kabel Ultra as shown here, you might want to open the tracking to improve the readability. The change might seem subtle, but the readability is improved and it can head off printing problems due to ink spread.

CHAPTER FOUR

SELECTING THE RIGHT TYPE FOR YOUR JOB

This book's chapter heading treatments use a variety of letter spacing, or tracking values, to create a certain stylized look.

WORD SPACING

The amount of space between words is called word spacing, naturally. The word spacing should not be so little that the words start to run into each other and not so much that your eye has trouble reading groups of words because it is interrupted by large white blocks. This value is predetermined by your font (and differs from font to font) but can be modified by changing the "optimum space" value in the H&J preferences in your page-layout program. For example, many commercial fonts have too much word spacing and can be improved by setting the word space to around 80 percent, but be sure to look over the type and make any necessary adjustments to this value until the desired color is achieved.

The amount of space between words is called word spacing, naturally. The word spacing should not be so little that the words start to run into each other, and not so much that your eye has trouble reading groups of words because it is being interrupted by large white blocks.

The amount of space between words is called word spacing, naturally. The word spacing should not be so little that the words start to run into each other, and not so much that your eye has trouble reading groups of words because it is being interrupted by large white blocks.

The amount of space between words is called word spacing, naturally. The word spacing should not be so little that the words start to run into each other, and not so much that your eye has trouble reading groups of words because it is being interrupted by large white blocks.

The word spacing should not be so little that the words start to run into each other, as in the first example, and not so much that your eye has trouble reading groups of words because it is interrupted by large white blocks, as in the second text block. The third example is the most balanced and the most readable.

MASSAGE THE RAPIST

MASSAGE THERAPIST

Look how an improperly placed word space can change the meaning totally, as is cleverly demonstrated in this promotional piece designed by Stephen Banham of The Letterbox.

Edit Hyphenation & Justification

Name:

80% word spacing

☑ **Auto Hyphenation**

Smallest Word:	3
Minimum Before:	2
Minimum After:	2

▣ Break Capitalized Words

Justification Method

	Min.	Opt.	Max.
Space:	60%	80%	100%
Char:	0%	0%	0%

Flush Zone: | 0" |

▣ Single Word Justify

Hyphens in a Row:	2
Hyphenation Zone:	0"

[OK] [Cancel]

Word spacing can be easily adjusted in QuarkXPress in the H&J dialog box by adjusting the "optimum space" value in the Justification Method column. A bit confusing, but very effective.

TYPOGRAPHIC TYPOS AND HOW TO AVOID THEM

When most of us squirmed through grammar lessons in grade school, we assumed that we were taught everything about reading and writing the English language that we would ever need to know. But if you use a computer for typesetting, this is no longer true. You need to know a few small but very important things if you want your work to be professional-looking and grammatically correct.

In some cases, there are several variations of punctuation that we were taught came in only one flavor, such as dashes, quotation marks, apostrophes and parentheses. While this might be true for handwriting, which is much more forgiving and individual in style, it isn't so for typesetting. Prior to desktop typography, it was left to typographers to know the differences between similar characters, where they were located on their keyboard and what was grammatically and typographically correct. Once designers, administrative assistants and the rest of us started setting type, a lot of this information fell through the cracks unless one was particularly knowledgeable about typography.

This problem was compounded by the fact that many of these characters are hard to find on the keyboard and require depressing combinations of keys to access them. This, to some degree, can be attributed to the engineers who designed the standard keyboard layout which we all use today. Since there was (and still is) room for only 256 characters on the keyboard layout, decisions had to be made with regard to which characters (including accented, foreign and mathematical characters) to include. Engineers tend to think mathematically and scientifically rather than grammatically and typographically, which resulted in some commonly used characters such as quotation marks and fractions being hidden or nonexistent.

HYPHEN/EN-DASH/EM-DASH

These three similar typographic characters are all horizontal lines of varying lengths. They all have different purposes, and the characters are often confused and misused, leading to inaccurate and unprofessional typography.

A *hyphen,* which is the shortest in length, is used to hyphenate words that break at the end of a line, or to connect elements of a compound word such as *go-between, ill-fated* and *run-of-the-mill,* and that's it. It is easily found on the keyboard to the right of the zero.

An *en-dash* is wider than a hyphen and narrower than an em-dash and is the least commonly used and understood of the three. It is used to indicate a continuation of time, years and dates (similar to using the words "to" and "from") such as 9 A.M.–5 P.M., Monday–Friday or May 2–7. It is accessed with the (option/hyphen) keys.

An *em-dash,* which is the longest of the three, is used to indicate a break in thought—as is illustrated in this sentence. It is also occasionally used to separate a thought within a sentence—such as this one—requiring an em-dash at the beginning and the end of the thought. It is accessed by pressing the (option/shift/hyphen) keys.

NOTE: Most of us have seen copy with two hyphens where an em-dash should be. This typographically incorrect—and ugly—practice is a holdover from typewriter days when there were no em-dashes on the keyboard, just hyphens. It has become a habit for some, especially if they used a typewriter before they were keyboarding on a computer.

The lengths of these characters are not standard, but vary from typeface to typeface, as do their sidebearings (the designated space to the right and left). Some en-dashes are the width of the lowercase *n,* and em-dashes the width of the *m;* others have no relationship at all. There are different philosophies behind these differences, but the principles of their usage remain the same.

Some room for artistic license is allowed in the use of these characters when their design or spacing seems out of proportion. Often, the em-dash seems much too wide for

As you can see here, the length and style of hyphens, en- and em-dashes vary tremendously from typeface to typeface.

9:00 – 5:00 P.M.
Monday–Friday
1984–1997

An en-dash is wider than a hyphen and narrower than an em-dash. It is used to indicate a continuation of time, years and dates.

the proportions of the typeface and creates a gaping hole in the color and texture of the text. In these cases, it is the practice of some designers to replace them with an en-dash. Another stylistic preference is to add a space before and after en- and em-dashes. Although this is not the norm (and not considered correct by some purists), if the dashes appear too tight, go ahead and do this. A better solution is to open the kerning between the dashes and their surrounding letters; this way you have more control over the space. Just remember to be consistent throughout, or the text will be an unprofessional jumble of varying styles.

This old town of Salem — my native place, though I have dwelt much away from it both in boyhood and maturer years — possesses, or did possess, a hold on my affection, the force of which I have never realized during my seasons of actual residence here.

This old town of Salem–my native place, though I have dwelt much away from it both in boyhood and maturer years–possesses, or did possess, a hold on my affection, the force of which I have never realized during my seasons of actual residence here.

This old town of Salem -- my native place, though I have dwelt much away from it both in boyhood and maturer years -- possesses, or did possess, a hold on my affection, the force of which I have never realized during my seasons of actual residence here.

An em-dash, which is longer than both the hyphen and en-dash, is used to indicate a break in thought as illustrated in the first paragraph. It can be replaced with an en-dash when the em-dash is extremely wide (second paragraph). The last paragraph illustrates what never to do! Using two hyphens to indicate an em-dash is a holdover from typewriter days and it is incorrect in fine typography. (Scarlet Letter)

His voice and laugh, which perpetually re-echoed through the Custom-House, had nothing of the tremulous quaver and cackle of an old man's utterance; they came strutting out of his lungs, like the crow of a cock, or the blast of a clarion.

A hyphen, which is shorter in length than the en- or em-dash, is used to hyphenate words that break at the end of a line, or to connect elements of a compound word such as those shown in this paragraph. (Scarlet Letter)

QUOTATION MARKS

One of the most misused typographic elements in desktop typography is the use of straight typewriter quotation marks, or "dumb" quotes, which are all too easily accessed on your keyboard, instead of true typographic quotation marks, also called "smart" quotes or "curly" quotes, which are harder to access. Smart quotes have an opening and a closing version, and are design sensitive or are designed differently for each typeface. "Dumb" quotes are usually simple tapered marks. They are also referred to as "primes" or inch and foot marks, which is a function they should actually be used for.

Misuse of "dumb" quotes is one of the most common typographic faux pas, which is repeatedly found in high-end print, multimedia advertising, movie credits, as well as non-professional work. Once again, the standard Mac layout designed by engineers, not graphic designers or typographers, put old-fashioned straight quotes in place of real quotes in the keyboard layout, and we are left to straighten out the mess.

There are several ways to address this problem. The easiest is to select "smart" quotes or "curly" quotes in the preferences of your software. (Most word-processing programs, as well as virtually all design programs, have this feature.) This works for any newly keyboarded copy. It doesn't always work when you import copy that has not been formatted this way, especially from a PC to a Mac.

The next best solution is to use one of the several small utilities or INITs that make this replacement automatically. There are several good shareware and freeware utilities for Macs and PCs, so look around for one that works easily and smoothly with your system.

The design of both "smart" and "dumb" quotes varies from face to face, but the rule is always the same: always use smart quotes (or never use dumb quotes, take your pick).

"smart" quotes
"dumb" quotes

"smart" quotes
"dumb" quotes

"smart" quotes
"dumb" quotes

"smart" quotes
"dumb" quotes

"smart" quotes
"dumb" quotes

"smart" quotes
"dumb" quotes

"smart" quotes
"dumb" quotes

"smart" quotes
"dumb" quotes

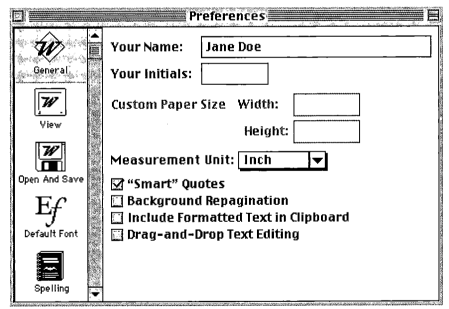

The automatic substitution of "smart" quotes can be set in the Preference files of most, if not all, word-processing and page-layout programs. Shown here are dialog boxes for QuarkXPress and Microsoft Word indicating "smart" quote usage.

Of course you can make these replacements manually, but it is easy to miss some, especially in long copy. Be sure to proof your work carefully if you do this. You can also use the "search-and-replace" feature of your software, but it is tedious and problematic, as you are replacing one design, which is the same for opening and closing quotes, with two separate designs. You can start by searching for a combination of a space before a "dumb" quote and replace with an opening "smart" quote, and conversely, search for a "dumb" quote with a space next to it, and replace with a closing "smart" quote. If you choose this method, proof your work carefully, as there might be some cases where it doesn't work properly.

These are the "smart" quote locations:

'	opening single quote:	option /]
'	closing single quote:	option / shift /]
"	opening double quote:	option / [
"	closing double quote:	option / shift / [

APOSTROPHES

The situation for apostrophes is the same as for quotes. That is, the default keyboard character is a straight typewriter apostrophe rather than the typographically correct "smart" apostrophe.

' apostrophe (or closing single quote): option / shift /]

SPACES

There is never a need for double spaces between sentences when setting type on your computer, as was done when using a typewriter. Curious how this practice came about? Just about all fonts on a computer (except Courier) have proportional spacing, and a single space creates the visual separation needed between sentences. Typewriter fonts are monospaced, which means that every letter takes up the same space, even the narrow letters. This makes for a very open-looking spacing, and a double word space was necessary to achieve a noticeable separation between sentences.

Many people still use double spacing on a computer and don't know it is incorrect in typography. Be particularly aware of this in copy that is given to you by others who are used to typewriter formatting. An easy way to fix these double spaces is to use the search-and-replace feature of your word-processing or design program so you can catch them all. If you fix them manually, it is easy to miss some; but if you choose to do it this way, proof the printed piece rather than on screen, where it is difficult to spot double spaces.

Alice replied eagerly,
for she was always
ready to talk about
her pet: `Dinah's our
cat. And she's such a
capital one for
catching mice you
can't think! And oh,
I wish you could see
her after the birds!
Why, she'll eat a lit-
tle bird as soon as
look at it!' This
speech caused a
remarkable sensation
among the party. Some
of the birds hurried
off at once.

The use of a double space to separate sentences was the accepted style for typewriter faces such as Courier shown here. It is incorrect in fine typography. (Alice In Wonderland)

Alice replied eagerly, for she was always ready to talk about her pet: 'Dinah's our cat. And she's such a capital one for catching mice you can't think! And oh, I wish you could see her after the birds! Why, she'll eat a little bird as soon as look at it!' This speech caused a remarkable sensation among the party. Some of the birds hurried off at once.

Alice replied eagerly, for she was always ready to talk about her pet: 'Dinah's our cat. And she's such a capital one for catching mice you can't think! And oh, I wish you could see her after the birds! Why, she'll eat a little bird as soon as look at it!' This speech caused a remarkable sensation among the party. Some of the birds hurried off at once.

The first paragraph shows the typographically incorrect practice of adding two spaces between sentences. It creates lots of holes throughout your text. The second example has been corrected to one space, and the color and texture of the text is improved as well as being typographically correct.

PARENTHESES, BRACKETS AND BRACES, ANGLED BRACKETS

These four symbols are always used in pairs, and all have a similar function, which is to enclose text not directly related to the context of the sentence.

Parentheses are the most common of the four and are primarily used to enclose interjected, explanatory or qualifying remarks. They also are of particular use for area codes and mathematical formulas, usually algebra.

Brackets, also called *square brackets,* are usually used to enclose copy within a parenthetical phrase, or more simply put, copy already enclosed within parentheses. Brackets are also used to enclose explanations or comments by the author, as well as for mathematical expressions and specific scientific compounds.

Braces, also called curly brackets, are a more decorative form of bracket and are traditionally used for certain mathematical expressions. They are occasionally used (with creative license) to replace parentheses in certain instances, such as to enclose a Web site or e-mail address.

The use of *angled brackets* to enclose text has become the accepted style in e-mail and on the Internet, particularly when copying part or all of an e-mail as part of a reply. There doesn't seem to be one definitive style, as it varies from browser to browser in the direction the brackets face, as well as whether they are used single or double: anything goes on the Internet, it seems.

These are the angled bracket locations:

‹ **opening single bracket :**	shift / option / 3
› **closing single bracket :**	shift / option / 4
« **opening double bracket :**	option / backslash
» **closing double bracket :**	shift / option / backslash

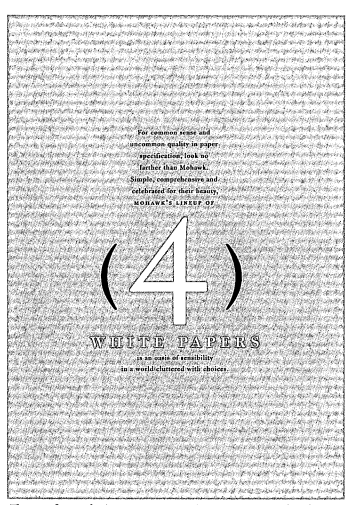

The use of parenthesis to accentuate an important typographic element in this piece designed by VSA Partners, Inc.

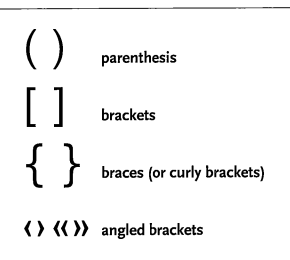

Brackets are sometimes used as design elements as seen in this business card by Michael Vanderbyl Design and in this promotional piece by Rigsby Design.

SIGNS, SYMBOLS AND DINGBATS

Several other typographic elements not mentioned yet will be needed from time to time. Not surprisingly, they are often misunderstood, as well as improperly or tastelessly used.

REGISTER, TRADEMARK AND COPYRIGHT SYMBOLS (® TM ©)

At some point, every designer needs to use one or more of these three symbols, and there are a few essential things to know about them. Nothing is worse than seeing a tiny, unreadable register mark in text, or a huge, annoying trademark in a headline.

The register, trademark and copyright symbols vary in design in every font. Sometimes they are design-sensitive and other times they are not. If the design appears inappropriate, illegible or unclear, you can substitute one from another font. Although many people prefer to use serif symbols with serif fonts and sans with sans, I personally prefer to use a nice, clean sans symbol for text usage (such as those from Helvetica or ITC Franklin Gothic), as they tend to be very readable and print cleanly at small sizes. When setting a headline, more latitude is given with the design, as readability is less of a problem.

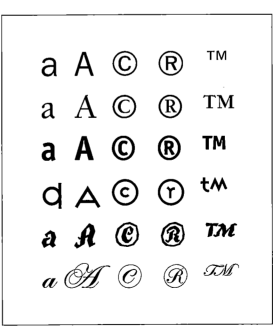

These three symbols shown next to other characters in the font vary in design in every font. Sometimes they are design-sensitive, and other times they are not.

Now let's talk about size, especially since this varies so much from font to font. When using a register symbol ® or a trademark symbol ™ after a word, the point size should be adjusted if necessary, independently from the rest of the text to look clean and legible yet unobtrusive. A general guideline for text is to make these symbols a little smaller than half the x-height; as your text gets larger, they can become proportionately smaller, especially in headlines. These symbols are legal designations, not exciting graphic elements, and making them too large can detract from the design.

The copyright symbol © is used in two manners: it is sometimes treated the same sizewise as the ® and the ™, but more frequently is used much larger. When it appears before a year, as in ©1998, or the name of a company, the size should be somewhere between the x-height and cap height. If you are using oldstyle figures for a year beginning with a figure one, be sure to match the size of the one and not some of the other taller numerals in the year.

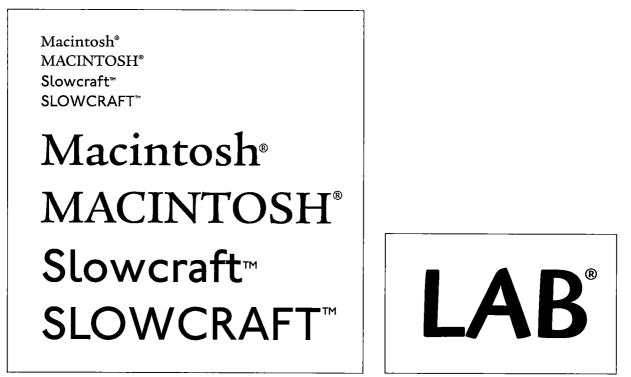

A general guideline for text is to make these symbols a little smaller than half the x-height; as your text gets larger, they can become proportionately smaller, especially when used in headlines.

© 1957 Slowcraft Inc.

© 1957 Slowcraft Inc.

©1957 SLOWCRAFT INC.

© 1957 SLOWCRAFT INC.

Placed before a year, the copyright symbol size should be somewhere between the x-height and cap height of the other type. Match the size of the one, not the other, taller numerals, when using old-style figures.

FRACTIONS

Do you know where fractions are found on your keyboard? On a Mac, they don't exist, unless there is a separate fraction font available as there is for Centaur and Bembo. A few fractions are sometimes available on a PC (¼, ½, ¾), but they are hidden away, and if you do use them, you can't combine the supplied fractions with other ones you create yourself, as they will undoubtedly look very different.

The easiest solution is to spell them out or use decimals wherever possible. If that doesn't work or seems inappropriate, try this: use the available numerals separated with a slash or a fraction bar (option/shift/1) as in 2¼. The fraction bar is weighted, spaced and angled differently than the slash (usually lighter and steeper in angle), but depending on their individual design and which method you use to create fractions, one might look better than the other. The slash bar usually works better for this method, but try them both. In general, this method of creating fractions usually looks cumbersome and can be confusing to read when there are several of them in a row.

6 1/2, 3 2/3, 10 3/4

The simplest method for creating fractions is to use the numerals separated by a slash bar without any adjustments. Easy, yes, but it doesn't look so great.

A better solution is to build fractions manually with the options available within your application. It is a bit time-consuming, but the result, although not perfect, is an improvement over the oversized versions.

Follow these steps:

1. Begin by typing in the numbers without spaces, making sure to use the fraction bar (option/shift/1).

2. Highlight the numerator (the part of the fraction above the bar), and make it super-script. (Superscript is a style designation available in most applications that shifts the character up.)

3. Reduce the point size of the numerator and the denominator (the part of the fraction below the bar), but not the fraction bar, until the fraction is the same height as the caps. (This will be somewhere between 50 and 75 percent.) Adjusting the spacing between these three elements with the kern feature may be necessary to even it out.

$$6\ 1/2$$
$$6\ \tfrac{1}{/2}$$
$$6\ \tfrac{1}{2}$$
$$6\ \tfrac{1}{2},\ 6\ \tfrac{1}{2},\ 6\ \tfrac{1}{2}$$

Take the extra steps necessary to make fractions look their best.

One problem with this method is that the weight of the fraction bar might be too heavy next to the reduced numerals, but it needs to remain cap height to look appropriate. Dependent upon the font used, this method can look either great or shoddy. But if you do make fractions this way, be sure to be consistent throughout your text.

Several software utilities and application extensions exist for making fractions. Look into them if you use a lot of fractions in your work, especially if using many different typefaces.

One other path to making great fractions can be taken if you are daring and motivated enough. You can actually customize your font by building your own fractions using Fontographer (see chapter 11). This does require the purchase of a rather expensive program, but the results can be the best by far, and will eliminate cumbersome work every time a fraction is needed.

BULLETS

A bullet is a large dot used to draw attention to a list of items that either have been extracted from your text or are independent of the text. The bullet that is part of your font (option/8) might need to be altered in size or position, as many are too large or small. Don't make the mistake of assuming that if it is in the font, it is the right size.

Bullets should be centered on either the cap height or x-height, depending on the nature of your listing. If all of your items begin with a cap, center the bullet on the cap, or a bit lower so it balances with the negative spaces created by the lowercase. If your items all begin with lowercase, center the bullets on the x-height. Inserting a space after the bullet is usually done to avoid crowding.

Bulleted points can be aligned two ways: the preferred way is to align the bullets with the left margin, but an alternative is for the bullets to overhang the margin with the actual text aligning with the left margin. Whichever style you choose, your listing will look best if items running more than one line indent so that all the copy aligns with itself and not with the bullet on the first line.

Bullets shouldn't be too large or too small.

If you want to be more creative, you can substitute other symbols for the bullets, such as squares or triangles. (See ITC Zapf Dingbats below and on page 135.) Just keep it simple and be consistent.

Things to have in your case at all times:
- A tuner
- New set of strings
- A few cords
- Tools for adjusting your guitar
- Metronome

Things to have in your case at all times:
- a tuner
- new set of strings
- a few cords
- tools for adjusting your guitar
- metronome

Bullets should be centered on either the cap height or x-height, depending on the nature of your listing.

These are some alternatives to bullets for the same effect:
- a tuner
- new set of strings
- a few cords
- metronome
- tools for adjusting your guitar
- Phillips screwdriver

If you want to be a bit more creative, you can substitute other symbols for the actual bullets, such as squares, triangles or check marks (just not all at once as shown here!).

ELLIPSES (DOT LEADERS)

The ellipsis (...) is a single character consisting of a series of three evenly spaced dots, used to indicate missing type or a continuation of type. It is a totally separate character (option/;) that is spaced the same as or more open than periods. If the spacing in the ellipsis is too tight, use three periods instead.

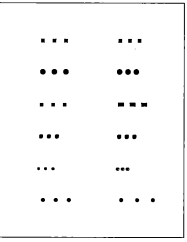

The size, design and spacing of ellipses vary from typeface to typeface compared to periods in the same font, as shown on the right.

An ellipsis in use in the title treatment of this large brochure (11" by 17" or 28cm by 43cm) designed by Rigsby Design.

ACCENTS

Most well-made fonts by reputable manufacturers include a selection of accents and other diacritical marks needed to set foreign words and names. Some are composite characters, which combine characters with accents or marks that are common to certain languages; others are the accents and marks by themselves which can be accessed with various key combinations. In order to position these floating accents properly, you need to be in an application that supports manual kerning. You actually have to kern the accent to the character until it is positioned directly above it. This is not possible in most word-processing programs.

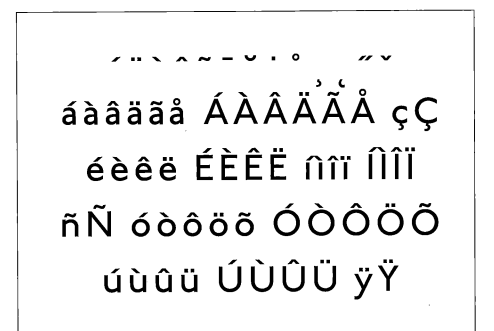

These are standard floating accents and accented characters available in many fonts. The floating accents can be used by kerning them heavily until they are above the desired character.

ITC ZAPF DINGBATS

ITC Zapf Dingbats is a wonderful nontypographic font consisting of many useful elements not available in other fonts. It is resident in many printers, meaning it was already in the brain of your printer when you bought it and is automatically available for use.

You will find many uses for Zapf Dingbats. Some of the most commonly used elements are solid circles, squares (and other geometric shapes), arrows, check boxes, hearts and leaf flourishes. Dingbats can be used for many things, such as calling attention to items in a list, separating paragraphs and indicating the end of an article. It is worth the time to become familiar with this font.

ITC Zapf Dingbats

CUSTOMIZING A FONT: DOS AND DON'TS

ometimes a font is missing a desirable character, symbol or logo, or the kerning just isn't right. Don't despair. It is possible to open a font with a font design program and make additions, changes and adjustments to suit your needs. If major changes, such as additional weights or totally revamped kerning, are needed, you might want to leave them to a professional. There are many individuals as well as companies that specialize in designing and customizing typefaces, and in many cases, it is preferable to go to these experts. But if the changes are minor or the budget is small, or you just want to play around and expand your skills, give it a shot.

The most commonly used and readily available font design program is Macromedia Fontographer. It is a wonderful font-manipulation tool that can do anything from making minor changes in the character set and layout in any font format and platform of an existing font (Mac or PC, Type 1 or TrueType), to designing high-quality, full-blown professional fonts with sophisticated kerning and hinting capabilities. The latter requires quite a bit of skill and experience, but small changes are well within the reach of the average designer.

IS IT LEGAL?

Before you begin to make alterations on your font, it is important to understand a few things about the legal and ethical issues surrounding fonts and typefaces. Did you know that when you buy a font, you do not actually own it, but are just buying a license to use it? Each manufacturer has different specifications regarding how many printers or CPUs (central processing units) you actually have the right to use it on, and this information is printed on the license agreement that you read before opening your font. It is similar to buying a music CD: you do not own that music, just the right to listen to it (but not copy or steal it).

Typefaces are designed by living, breathing people, men and women

Gigi
abcdefghijklmnopqrstuvwxyz
ABCDEFGHIJKLMNOPQRSTUVWXYZ
0123456789!?$¢£ƒ&

Jill Bell is an accomplished type designer as well as a letterer and calligrapher. "I began my career as a lettering artist imitating rubber stamp prints and forging my parent's signatures." When she is not designing beautiful letters, she paints, writes, sings and studies Eastern philosophy.

who put their hearts, souls and valuable time into them without any guarantee of a return for their efforts. In most cases, they get a royalty every time one of their fonts is sold. When you give a copy of a font to a friend or buy a knockoff from a disreputable vendor, you are robbing someone of that royalty. Typeface protection in the United States. is inadequate at best, and even the existing laws are often unenforceable. So in many cases it is up to the end user such as yourself to behave responsibly and ethically in order to create an environment in which type designers continue to design typefaces.

Typeface protection varies from country to country; in the United States, it is a mixed-bag situation. The good news is that the font software, or more specifically the digital data itself, is protected; so is the name of the typeface if the manufacturer registered it with the patent office. This means that if you take an existing font (that is, the actual digital data), change the name and market it as your own, you are stealing that font software and it is illegal. Likewise, if the manufacturer has copyrighted the name of the font, you can't use that name, even if it is for a different design.

ITC Luna

abcdefghijklmnopqrstuvwxyz
ABCDEFGHIJKLMNOPQRSTUVWXYZ
0123456789!?$¢£ƒ&

Akira Kobayashi is a free-lance type designer living and working in Tokyo, Japan. He also finds time to teach lettering at an art school. His recent venture in the art of letterpress printing has led to the opportunity to work at a letterpress workshop in a printing museum in Tokyo.

As a designer of graphics, lettering, illustration and collage, Teri Kahan had created hundreds of lettering styles for logos, packaging, posters and videos before any of them were turned into typefaces. Since then, she has designed two type-faces and two design fonts including ITC Cherie, which she describes as "a sophisticated blend of multiple historic styles."

ITC Cherie

ABCDEFGHIJKLMNOPQRSTUVWXYZ
ABCDEFGHIJKLMNOPQRSTUVWXYZ
0123456789!?$¢£ƒ&

Balboa

abcdefghijklmnopqrstuvwxyz
ABCDEFGHIJKLMNOPQRSTUVWXYZ
0123456789$¢£ƒ&!?

Jim Parkinson is one of the lucky few who has been able to devote his career solely to type. He specializes in typeface design and typographic logos and has designed dozens of typefaces for publications as well as for commercial use. He says, "I was born in Richmond, California, in 1941, and have been lettering ever since."

The bad news is that the actual design of the typeface is not protected. Unfortunately, the U.S. Congress has not noticed or acknowledged that one "A" is different from another "A." We are referring to the actual design of the character here, not the digital representation of it. This is why there are so many knockoffs and pirated fonts with names that sound like, but are a little different from, the typefaces they came from. So although technically it might not be illegal to copy someone else's design, it is extremely unethical, as it is stealing another person's concept and hard work.

It is OK to customize a font as long as it is for your own personal use and not for resale or use by more than the number of printers specified by the manufacturer. If you are customizing a font for a client for commercial or large-scale use, contact the font manufacturer for permission and/or the appropriate procedure. It is important to respect the creative process and the rights of the designers, as well as the manufacturers that support their efforts, if there is to be a continuous supply of fresh, new typeface designs.

Timothy Donaldson is a prolific type designer as well as a graphic artist, hand-letterer and calligrapher. He also describes himself as a teacher who is interested in learning. Tim says, "I am a shape junkie, and letterforms are some of the strangest shapes, simultaneously so mysterious and functional." Tim goes under the nom de plume "kingink" and lives in what he calls the "black country" of England with his human and feline family.

Postino
abcdefghijklmno
pqrstuvwxyz
ABCDEFGHIJKLMNO
PQRSTUVWXYZ
0123456789!?$¢£ƒ&

ADJUSTMENTS FOR EXISTING FONTS

The intention of this chapter is not to teach you Fontographer or any other font-manipulation program. That you can learn on your own from the user's guide supplied with the program (supplemented if you wish by an excellent book called *Fontographer: Type By Design*, by Stephen Moye). The goal here is to whet your appetite, typographically speaking, and to encourage you to take control of your typographic destiny with options you never thought you had.

What are some of the things you might want to do? The possibilities are endless! Many of these modifications will eliminate the need to make more time-consuming changes on every document you create in your page-layout program. Just be careful until you have a finely developed eye, as you might not know how much of an adjustment to make. The rule of thumb should be to always do less rather than more.

You can:

- Adjust existing symbols and add a new one

- Adjust the size and/or position of the bullets to your liking, as they are often too small.

- Create your own fractions. Professional-looking fractions can become easily accessible in the position of your choice. The numerals and fraction bar (preferable to the slash, if it is available, due to the different angle) should already exist in the font. So it is just a matter of copying them into an unassigned position, reducing the numerals to about 50 to 60 percent and positioning them to the upper left and lower right of the bar. The

You can adjust the size and/or position of the bullet.

resulting numerals will look too light, so there are two things you can do to correct this. If there is a bold version of the typeface, you might try using those numerals so when they reduce, they are closer in color to the font you are working on. The other solution is to embolden the numerals with the "change weight" feature in Fontographer or other font-manipulation program. Follow the same procedure with any other fractions you make for consistency.

*To create fractions in Fontographer,
begin by copying the slash or the fraction
bar (whichever works better) into an
unassigned position.*

*Copy and paste the numerals, shifting
them into position.*

Transform

Center transformations around:

Center of selection ▼

First transformation:

Scale uniformly ▼ | 60 | percent

Then:

Do nothing ▼

Then:

Do nothing ▼

Then:

Do nothing ▼

Transform
Cancel

*Reduce the numerals by 50 to 60 per-
cent with the "transform/scale uni-
formly" function and realign them.*

Change Weight

Change by: [15] em units

☑ Correct path direction first
☐ Don't change vertical size
☐ Don't change horizontal size

OK
Cancel

*Heavy up the weight of the numerals to
match the color of the fraction bar.*

- Adjust the size and position of the copyright, register and trademark symbols, or add them if they don't exist.

- Create and add the new Euro currency symbol to any font by starting with the cap C and adding the horizontal bars. This requires a little more skill with the software, so be patient and give yourself lots of time to get it right.

- Adjust spacing and kerning.

- Adjust the word spacing of any font. To do this, you must change the width of position 32 and 202. If this is all you do to a font, it can make a dramatic difference in your text, and you won't have to make this adjustment in your page-layout program every time you use it.

Adjust the copyright symbol...

...register mark...

...and trademark symbol to your liking.

The new Euro currency symbol.

FranklinGothicITCbyBT-Book

View by: Decimal

0	1	2	3	4	5	6	7	8	9	10	11	12	13	14	15	16	17	18	19	20	21	22
	Ð	Ö	Ł	ǂ	Š	š	Ý	ý			Þ	þ		Ž	ž						¾	¼

23	24	25	26	27	28	29	30	31	32	33	34	35	36	37	38	39	40	41	42	43	44	45
1	¾	3	2	↕	—	×			■	!	"	#	$	%	&	'	()	*	+	,	-

46	47	48	49	50	51	52	53	54	55	56	57	58	59	60	61	62	63	64	65	66	67	68
.	/	0	1	2	3	4	5	6	7	8	9	:	;	<	=	>	?	@	A	B	C	D

69	70	71	72	73	74	75	76	77	78	79	80	81	82	83	84	85	86	87	88	89	90	91
E	F	G	H	I	J	K	L	M	N	O	P	Q	R	S	T	U	V	W	X	Y	Z	[

92	93	94	95	96	97	98	99	100	101	102	103	104	105	106	107	108	109	110	111	112	113	114
\]	^	_	`	a	b	c	d	e	f	g	h	i	j	k	l	m	n	o	p	q	r

115	116	117	118	119	120	121	122	123	124	125	126	127	128	129	130	131	132	133	134	135	136	137
s	t	u	v	w	x	y	z	{	\|	}	~		Ä	Å	Ç	É	Ñ	Ö	Ü	á	à	â

138	139	140	141	142	143	144	145	146	147	148	149	150	151	152	153	154	155	156	157	158	159	160
ä	ã	å	ç	é	è	ê	ë	í	ì	î	ï	ñ	ó	ò	ô	ö	õ	ú	ù	û	ü	†

161	162	163	164	165	166	167	168	169	170	171	172	173	174	175	176	177	178	179	180	181	182	183
°	¢	£	§	•	¶	ß	®	©	™	´	¨		Æ	Ø		±			¥	µ		

184	185	186	187	188	189	190	191	192	193	194	195	196	197	198	199	200	201	202	203	204	205	206
			ª	º		æ	ø	¿	¡	¬		ƒ			«	»	…	■	À	Ã	Õ	Œ

207	208	209	210	211	212	213	214	215	216	217	218	219	220	221	222	223	224	225	226	227	228	229
œ	–	—	"	"	'	'	÷		ÿ	Ÿ	/	¤	‹	›	fi	fl	‡	·	,	„	‰	Â

230	231	232	233	234	235	236	237	238	239	240	241	242	243	244	245	246	247	248	249	250	251	252
Ê	Á	Ë	È	Í	Î	Ï	Ì	Ó	Ô		Ò	Ú	Û	Ù	ı	^	~	¯	˘	˙	˚	

253	254	255	256
˝	˛	ˇ	

To change the word spacing of a font, change the width of positions 32 and 202.

- Open or close the overall spacing of the font (some older fonts are way too tight!) by adding or reducing the same value on the right and left of each character. There is an automatic function for this under "set metrics."

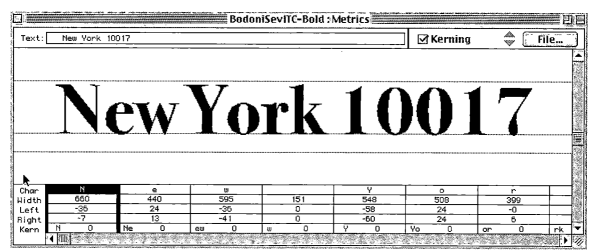

You can open or close the overall spacing of the font by increasing or reducing the space on the right and left of each character using the "set metrics" function.

- Make individual kern adjustments. This is great for problematic character combos (Ty, Yo, etc.) or to kern numerals (especially the one), which are often left unkerned. (Just make sure you don't need to use this font for charts where the numerals need to remain unkerned to align vertically.) If you really want to have professional-looking type, kern lowercase characters to the commonly used punctuation, such as periods and commas, register and trademark symbols to periods, and opening and closing quotation marks to certain characters as well as to periods and commas. You'll find many other possibilities as you get the hang of it.

There are other more complex things you can do to make a font more robust and useful, such as adding small caps or oldstyle figures, and making weight adjustments, but they require much more skill and design expertise to accomplish them in a professional manner. Quite honestly, if you desire these features, you are probably better off purchasing a font that has them, as it will be professionally designed and executed. Type design is not something that can be learned in a day or over a weekend, but if you have the talent, desire and motivation, it is within reach.

These numbers are tabular and cry out for kerning if you don't need them for tables. The "Yo" combo needs work too.

Click and drag the kerning handle in the center of the character to slide everything to the right of the "Y."

The tabular numerals before kerning...

...and after.

The final result...a tremendous improvement over the original.

DESIGNING YOUR OWN TYPEFACE

Designing a typeface is not for the faint of heart. In most cases designing a full-blown, professional-quality typeface should be left to those type designers, letterers and calligraphers who have a foundation in letterforms and a strong interest in typeface design, and the time, patience and perseverance to pursue it. But if your heart is hardy, read on!

Your design idea might be one that is for your own personal use, a custom job for a client, or a more serious typographic venture that you might want to make available to others. In any case, be realistic and allow your first exploration to be a learning experience more than anything else. No matter how terrific your first creation might seem to your own eyes, a type designer (and a high-quality typeface) is not made in a day. Learning how to draw in PostScript with bezier curves takes a lot of practice and can be very frustrating until you get to the point where it begins to feel natural and instinctive. In addition, *understanding* the concepts of spacing, kerning and hinting are not the same as *applying* them to an actual typeface, just as appreciating music or fine art is not the same as creating it. So be patient when honing your new skills; your next type venture will most certainly improve from an aesthetic as well as a technical standpoint. Keeping this in mind, it is best to start simple; save your more complicated ideas for later.

HANDWRITING FONTS: A GOOD PLACE TO BEGIN
A relatively simple and fun way to get your typographic feet wet is by making a font out of your (or anyone else's) handwriting. These days, many of us use our computer for much of the writing we do, including invitations, journals, personal notes and letters. Most typefaces are too formal for these projects, but a handwriting-style font will do nicely and maintain that personal, low-tech look. In fact, sometimes it is hard to tell the difference between an actual handwritten piece and a font unless you know what to look for. The handwriting you select should be an unconnected, non-cursive print, not a

ITC Grimshaw Hand

A relatively simple and fun way to get your typographic feet wet is by making a font out of your (or anyone else's) handwriting. A handwriting-style font is very unique and individualistic, and can maintain that personal, low tech look and feel in a very high tech world.

ITC Johann Sparkling

A fun and relatively simple way to get your typographic feet wet is by making a font out of your (or anyone else's) handwriting. A handwriting-style font can maintain that personal, low tech look and feel in a very high tech world.

ITC Dartagnon

A relatively simple and fun way to get your typographic feet wet is by making a font out of your (or anyone else's) handwriting. A handwriting-style font is very unique and individualistic, and can maintain that personal, low tech look and feel in a very high tech world.

These handwriting fonts show the extreme diversity of this style of typeface. International Typeface Corporation's program to nurture and develop these kinds of designs has provided a wealth of new and interesting typography.

ITC Grimshaw Hand designed by the late Phill Grimshaw. Based on his own handwriting, this typeface is one of many distinctive typefaces designed during the notable career of this designer of letterforms. He believed "If you enjoy what you do, and you're lucky enough to be good at it, just do it for that reason."

ITC Johann Sparkling designed by Viktor Solt. "ITC Johann Sparkling is intended to close the gap between highly formal copperplate scripts and the scribbled look of 'true' handwriting," says Vienna designer Viktor Solt.

ITC Dartagnon designed by Nick Cooke. "It's a long shot, but it might just work as a font." That's what this English type designer thought after he'd doodled a few free-flowing letters with a chunky pencil one day in London.

loopy, connecting script that might create problems when letters are combined. Once you decide on a handwriting to use, the next step is to have each character written several times so you can pick the best one. Don't forget to include numbers, punctuation and all the signs and symbols included in most fonts. It is best to gang up these characters on one or several 8½" x 11" sheets of paper or vellum to make them easier to scan later. Make sure you indicate a baseline, or you will have a lot of trouble later lining them all up in your font-manipulation software.

You might want to try different pens and markers as well as different smooth-textured surfaces, and do a test before drawing the complete character set. Your artwork will then need to be scanned, converted into digital data with a program such as Adobe Streamline, and imported into Fontographer or another font software program. Refer to Fontographer's user's guide for detailed instructions.

Once the entire process is completed, a font is created and you can see your handwriting coming off your printer. You will be amazed at the final product. Just keep in mind that it is the nature of a handwriting font to be very quirky, individual and informal—it is a very forgiving place to start, and it isn't supposed to be perfect!

ITC Deelirious

A relatively simple and fun way to get your typographic feet wet is by making a font out of your (or anyone else's) handwriting. A handwriting-style font is very unique and individualistic, and can maintain that personal, low tech look and feel in a very high tech world.

ITC Zemke Hand

A relatively simple and fun way to get your typographic feet wet is by making a font out of your (or anyone else's) handwriting. A handwriting-style font is very unique and individualistic, and can maintain that personal, low tech look and feel in a very high tech world.

ITC Deelirious designed by Dee Densmore D'Amico. The name grows out of the Ds in her name—Dee Densmore D'Amico—and the typeface itself grows out of her distinctive, energetic handwriting (or hand printing).

ITC Zemke Hand designed by and based on the handwriting of illustrator Deborah Zemke. Deborah jokes that seeing a font of her writing "gives me a bit of an identity crisis."

THREE APPROACHES TO DESIGNING A TYPEFACE

If you've decided to do something other than a handwriting font, there are some decisions to be made on how to begin, as well as a different approach to the entire design process. But before you begin, it is a good idea to check foundries and resellers to make sure your idea hasn't already been done. Why spend hours, days and possibly weeks and months reinventing a wheel? Be sure to start with something that is not available from other sources.

There are several different approaches to designing a typeface using a computer. They are all used successfully by different designers, and all have their pros and cons.

The most traditional way is to develop a finished drawing of your alphabet before scanning and importing into Fontographer, after which you can clean it up, add spacing and kerning, run text tests, and fine-tune. This approach requires that you know how to draw pretty well, which is not necessarily a skill that today's neophyte type designers have. Not too long ago, hand-drawing the final artwork was the only way to design a typeface, which was then given to a manufacturer. There was no testing at large and small sizes, no letterform templates, no creating and interpolating other weights on the fly, etc. Many typefaces took months and sometimes years to complete, but every shape, every curve was intentional and well thought-out.

"I don't sit down to design a font. The design for my fonts mostly originates from lettering. All of my typefaces are drawn by hand with a brush or a pen to retain a handwritten feel. I'll do some touching up and then digitize and touch up some more. Often I'll have to go back and chose different versions of some characters or create entirely new ones if they don't work well when placed with other characters".

—Jill Bell

A more commonly used method is to begin with a drawing or rough sketch of your concept, then complete and fine-tune your typeface after scanning. It is a good idea to begin with as tight a drawing as possible to get you to think about and make deliberate decisions regarding the shapes, curves and other characteristics of your design. The computer imparts a personality of its own to any work done on it, so in order to have as much control over the final product as possible, make as many decisions as you can before scanning.

"I rarely draw sketches of complete alphabets. I always draw sketches on paper; usually ten to twenty characters are drawn by hand and the rest are designed on screen. The drawings are sometimes scanned and traced by hand; sometimes they are not scanned and in that case, I design directly on screen, putting the sketches alongside."

— Akira Kobayashi

These days, more and more designers are designing an entire typeface on the computer screen; that is, they do no actual hand-drawing at all. This takes a high degree of skill in PostScript drawing tools, as well as a highly developed ability to conceptualize and actualize a concept on screen. This approach might work well for some very geometric designs, but in general, it is not recommended for neophytes. The danger here is that you will leave all the design decisions and fine-tuning of shapes up to the quirks and personality of the drawing tools of your software combined with the limitations of your own skills. Unless you are highly skilled at fine-tuning them, most computer-generated typefaces will have a certain look that identifies the designer as a novice.

"I used to do sketches and scan them. . .but now I just draw directly on screen. The scanned sketches evolved so quickly, they were instant rubbish. A waste of time."

— Jim Parkinson

PROFESSIONAL GUIDELINES

Once you've decided on a beginning approach, the following guidelines will help you to proceed in a smooth, logical way toward developing your seed of an idea into a full-blown, well-thought-out typeface.

1. Begin with a strong, well-developed concept and follow it throughout the design.

2. Have a clear idea of what you intend your design to be used for, whether it be text, display or midrange sizes.

3. Begin by drawing a test word, such as "hamburgefonts," in lowercase, scan it, and then import it into your font-manipulation software. This test word contains most of the character shapes that are used in the rest of the alphabet.

Hamburgefonts
HAMBURGEFONTS

4. Next, set copy with these characters and look it over carefully at various sizes. Check characters for consistent width, stroke thickness and overall color. At the same time, adjust the side bearings (space on the right and left of the character) to allow for optimum even color.

5. When these look good, work on the caps, figures and the rest of the character complement. Go through the same testing procedure.

6. A good way to work is to create a test document that shows all lowercase combinations, important cap-to-lowercase combinations, as well as a text block. The idea is to adjust both the actual characters and the side bearings to create good overall color and spacing.

7. *Do not kern* the typeface until you have done all of the above. Kerning should be the icing on the cake and should not be used as a Band-Aid to fix poor spacing. More kern pairs does not necessarily mean a better looking font if the original fit is poor.

8. Get away from your project when you can't see it objectively anymore, and take a fresh look in the morning. Our eyes and capacity to observe detail have a daily peak and ebb. Know what your peak is and do your most intensive work then.

9. And finally, know when to let go: you can't carry your "typechild" forever.

Typographic excellence is result of nothing more than attitude. Its appeal comes from the understanding used in its planning; designers must care. Contemporary advertising, perfect integration elements often demands unorthodox may requires use compact whatever tooth quiver jellyfish practically expectorated by mad hawk; victors flank gyp who mix ITC QUARTZ HELP BOLTING TENT CONTRAINDICATEDLY SUPERB (247) 371-0639. (800) 754-4732.

AbAcAdAeAfAgAhAiAkAlAmAnApAqArAsAtAuAvAwAxAyAz
BaBeBiBlBoBrBuBy CaCeChCiCoCrCuCyCz DaDeDiDlDoDrDuDy
EaEbEcEdEfEgEhEiEjEkElEmEnEoEpEqErEtEuEvEwExEyEz
FaFeFiFlFoFrFu GaGeGiGoGrGuGy HaHeHiHoHuHy
IcIdIfIgIlImInIoIpIrIsI tJaJeJiJoJu KaKeKiKlKnKrKu
LaLeLiLoLu MaMeMiMoMuMy NaNeNiNoNuNy
OaObOcOdOfOhOiOlOmOnOpOrOsOtOuOvOwOx
UdUnUpUs PaPePiPoPrPsPtPuPy Qu RaReRiRoRu
SaScSeShSiSkSlSmSnSoSpSqStSuSwSy TaTeThTiToTrTsTuTwTy
VaVeViVo WaWeWhWiWoWrWuWy YaYeYiYoYu ZaZeZiZo
aabacadaeafagahaiajakalaamanaoapaqarasatauavawaxayaza
bbcbdbebfbgbhbibbkblbmbnbobpbqbrbsbtbubvbbwbxbybzbc
cdcecfcgchcicjckclcmcncocpcqccrcsctcucvcwcxcyczc
ddedfdgdhdidjdkdldmdndodpdqdrdsdtdudvdwdxdydzd
eefegeheiejekelemeneoepeqereseeteuevewexeyeze
ffgfhfifjfkflfmfnfofpfqfrfsftfufvfwfxfyfzf
gghgigjgkglgmgngogpgqgrgsgtgugvgwgxgygzg
hhihjhkhlhmhnhohphqhrhshthuhvhwhxhyhzh
iijikiliminioipiqirisitiuiviwixiyizjkjljmjnjojpjqjrjsjtjujvjwjxjyjzj
kklkmknkokpkqkrksktkukvkwkxkykzk llmlnlolplqlrlsltlulvlwlxlylzlm
mnmompmqmrmsmtmumvmwmxmymzm nnonpnqnrnsntnunvnwnxnynzn
oopoqorosotouovowoxoyozo ppqprpsptpupvpwpxpypzp
qqrqsqtquqvqwqxqyqzq rrsrtrurvrwrxryrzr sstsusvswsxsyszs ttutvtwtxtytzt
uuvuwuxuyuzu vvwvxvyvzv wwxwywz wxxyxzx yyzy zz
a. b. c. d. e. f. g. h. i. j. k. l. m. n. o. p. q. r. s. t. u. v. w. x. y. z.
a, b, c, d, e, f, g, h, i, j, k, l, m, n, o, p, q, r, s, t, u, v, w, x, y, z,
a'b'c'd'e'f'g'h'i'j'k'l'm'n'o'p'q'r's't'u'v'w'x'y'z'
'a' 'b' 'c' 'd' 'e' 'f' 'g' 'h' 'i' 'j' 'k' 'l' 'm' 'n'
'o' 'p' 'q' 'r' 's' 't' 'u' 'v' 'w' 'x' 'y' 'z' ." ,"
"a" "b" "c" "d" "e" "f" "g" "h" "i" "j" "k" "l" "m"
"n" "o" "p" "q" "r" "s" "t" "u" "v" "w" "x" "y" "z"
a;b;c;d;e;f;g;h;i;j;k;l;m;n;o;p;q;r;s;t;u;v;w;x;y;z;
a:b:c:d:e:f:g:h:i:j:k:l:m:n:o:p:q:r:s:t:u:v:w:x:y:z:
-a-b-c-d-e-f-g-h-i-j-k-l-m-n-o-p-q-r-s-t-u-v-w-x-y-z-
-A-B-C-D-E-F-G-H-I-J-K-L-M-N-O-P-Q-R-S-T-U-V-W-X-Y-Z-
A. B. C. D. E. F. G. H. I. J. K. L. M. N. O.P. Q. R. S. T. U. V. W. X. Y. Z.
A, B, C, D, E, F, G, H, I, J, K, L, M, N, O,P, Q, R, S, T, U, V, W, X, Y, Z,
A'B'C'D'E'F'G'H'I'J'K'L'M'N'O'P'Q'R'S'T'U'V'W'X'Y'Z'
'A' 'B' 'C' 'D' 'E' 'F' 'G' 'H' 'I' 'J' 'K' 'L' 'M' 'N'
'O' 'P' 'Q' 'R' 'S' 'T' 'U' 'V' 'W' 'X' 'Y' 'Z'
"A""B""C""D""E""F""G""H""I""J""K""L""M"
"N""O""P""Q""R""S""T""U""V""W""X""Y""Z"
A;B;C;D;E;F;G;H;I;J;K;L;M;N;O;P;Q;R;S;T;U;V;W;X;Y;Z;
A:B:C:D:E:F:G:H:I:J:K:L:M:N:O:P:Q:R:S:T:U:V:W:X:Y:Z:
AABACADAEAFAGAHAIAJAKALAMANAOPAQARASATAUAVAWAXAYAZA
BBCBDBEBFBGBHBIBJBKBLBMBNBOBPBRBSBTBUBVBWBY
CCECFCHCICKCLCMCNCOCRCSCTCUCVCWCXCYCZC
DDEFDGDHDIDJDKDLDMDNDODPDRDSDTDUDVDWDXDYD
EEFEGEHEIEJEKELEMENEOEPEQERESETEUEVEWEXEYEZE
FFGFHFIFJFKFLFMFNFOFPFQFRFSFTFUFVFWFXFYFZF
GGHGIGJGKGLGMGNGOGPGQGRGSGTGUGVGWGXGY

This test document shows lowercase combinations, important cap-to-lowercase combos, as well as a text block. The idea is to adjust both the actual characters and the side bearings to create good overall color and spacing.

BIBLIOGRAPHY

A Chronology of Printing, by Colin Clair, 1969, Frederick A. Praeger, Publishers.

The Desktop Style Guide, by James Felici, 1991, Bantam Books.

Digital Typography Sourcebook, by Marvin Bryan, 1997, Wiley Computer Publishing.

Fontographer: Type by Design, by Stephen Moye, 1995, MIS Press

Herb Lubalin, Art Director, Graphic Designer and Typographer, by Gertrude Snyder and Alan Peckolick, 1985, American Showcase, Inc.

How to Boss Your Fonts Around, by Robin Williams, 1994, Peachpit Press, Inc.

Jargon, An Informal Dictionary of Computer Terms, by Robin Williams with Steve Cummings, 1993, Peachpit Press, Inc.

The Mac Is Not a Typewriter, by Robin Williams, 1990, Peachpit Press, Inc.

The Macintosh Font Book, by Erfert Fenton, 1989, Peachpit Press, Inc.

The Story of Writing, by Andrew Robinson, 1995, Thames & Hudson, Ltd.

Type and Typography: The Designer's Book of Type, by Ben Rosen, 1976, Van Nostrand Reinhold Company Inc.

Type from the Desktop, by Clifford Burke, 1990, Ventana Press.

Type in Use: Effective Typography for Electronic Publishing, by Alex White, 1992, Design Press, Tab Books, a division of McGraw-Hill, Inc.

Typographic Communications Today, by Edward M. Gottschall, 1989, MIT Press.

Typographic Design: Form and Communication, by Rob Carter, Ben Day, Philip Meggs, 1985, Van Nostrand Reinhold Company, Inc.

P. 14 © Axel Poignant Archive.

P. 15 © 1997 William P. Thayer.

P. 18 © 1999 Sumner Stone. All rights reserved.

P. 21 © International Typeface Corporation.

P. 22 © Rhoda S. Lubalin (Estate of Herb Lubalin).

P. 27–30 © Adobe and Adobe Type Manager are trademarks of Adobe Systems Incorporated.

P. 31 © Extensis Products Group, a division of Creativepro.com, Inc.

p. 44 (top) © 1991–99 Jim Spiece, Spiece Graphics, Ft. Wayne, Indiana; (bottom) © Courtesy Mysterious Press/Warner Books.

P. 45 © Robert Greenhood.

P. 47 (top) © 2000 The Yupo Corporation; (bottom) © 1997 Paul Elledge Photgraphy, Inc.

P. 48 (top left) © 1994 Sony Music Entertainment, Inc.; (right) © 1994 Skillsbank Corporation. This advertisement is a copy of a previous advertising campaign and is not representative of any current promotions offered by Skillsbank Corporation; (left bottom) © 1990 Jill Bell.

P. 49 (top left) © Tom Connor, Jim Downey; (top right) © David DeRosa; (top lower right) © Leslie Singer; (center) © Global-Dining, Inc.; (bottom right) © 2000 Juvenile Diabetes Foundation.

P. 50 (top) © YWCA of Rochester and Monroe County (NY). No materials shall be reproduced without permission of the YWCA of Rochester and Monroe County; (bottom) © 2000 The Yupo Corporation.

P. 51 © Courtesy of Mohawk Paper Mills, Inc.

P. 55 © The Letterbox.

P. 56 (top right) © 2000 The Yupo Corporation; (center) © International Typeface Corporation; (bottom right) © Andrew M. Newman.

P. 57 (top left) © Houghton Mifflin Company; (top right) © Courtesy of Alfred A. Knopf Publishers, Inc.; (bottom left) © Andrew M. Newman.

P. 62 © The Yupo Corporation.

P. 63 (top) © Fortune Brands, Inc.; (bottom) © Citizens Utilities.

P. 64 (left) © Doyle Partners; (right) © Design firm: Hornall Anderson Design Works, Inc./Client: Mohawk Paper Mills.

P. 65 © Vanderbyl Design.

P. 70 © International Typeface Corporation.

P. 71 © Doyle Partners.

P. 74 (top) © Design firm: Hornall Anderson Design Works, Inc./Client: Tree Top; (bottom) © Doyle Partners.

P. 78 (top) © NLP IP Company; (bottom) © The Regents of the University of California, published by the UCLA Center for the 17th- & 18th-Century Studies and William Andrews Clark Memorial Library.

P. 80 © Courtesy of Mohawk Paper Mills, Inc.

P. 91 © Citizens Utilities.

P. 96 © International Typeface Corporation.

P. 97 (top) © Design firm: Hornall Anderson Design Works, Inc./Client: Mohawk Paper Mills; (bottom) © 1995 NCLR (Eva Roberts, art director and designer; Stanton Blakeslee, designer; Alex Albright, editor).

P. 98 © Design firm: VSA Partners, Inc./Client: C. Stilp, Fox River Paper Co.

P. 102–103 © Quark, Inc.

P. 106 © International Typeface Corporation.

P. 107 © 1994–1995 Macromedia, Inc., 600 Townsend St. San Francisco, CA 94103 USA. All rights reserved.

P. 108 © Quark, Inc.

P. 109 © Design firm: VSA Partners, Inc./Client: C. Stilp, Fox River Paper Co.

P. 111 © 1994–1995 Macromedia, Inc., 600 Townsend St. San Francisco, CA 94103 USA. All rights reserved.

P. 112 © Quark, Inc.

P. 115 (top) © The Letterbox; (bottom) © Quark, Inc.

P. 121 (top) © Quark, Inc.; (bottom) © Microsoft.

P. 124 © Courtesy of Mohawk Paper Mills, Inc.

P. 125 (left) © Design firm: Rigsby Design; (right) © Vanderbyl Design.

P. 132 © Design firm: Rigsby Design.

P. 138 © Jill Bell.

P. 139 (top) © Akira Kobayashi; (center) © Teri Kahan; (bottom) © Jim Parkinson.

P. 140 © Timothy Donaldson.

P. 141–145 © 1994–1995 Macromedia, Inc., 600 Townsend St. San Francisco, CA 94103 USA. All rights reserved.